HOW TO USE
THE GOPRO®
HERO 4 BLACK

The Book For Your Camera-

the HERO4 BLACK Edition

by Jordan Hetrick

KAISANTI PRESS

PUBLISHED BY **Kaisanti Press**
A Division of S.S. Publishing Group

HOW TO USE THE GoPRO HERO4 BLACK

Cover and interior layout design by Debs Marie.

HOW TO USE
THE GOPRO HERO 4 BLACK

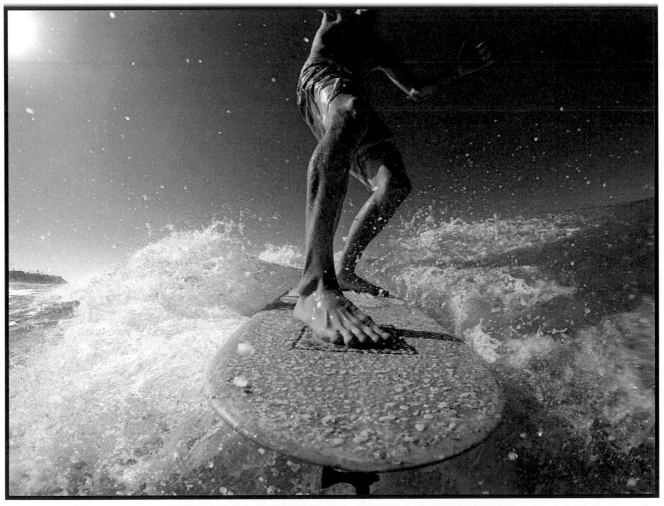

Photo taken in Time Lapse Photo Mode at 12 MP WIDE with the HERO4 Black camera using the Surfboard Mount with a camera extension. Learn how to set up a shot like this in Step 2- Mounting.

INTRODUCTION

GoPro cameras are the perfect complement to our active lives because they have taken technology that used to be out of reach for most people and put it right into our hands (and on our helmets, vehicles, bikes, and boards). Anywhere you turn, you will see people using GoPro cameras in tons of different ways to document their own journeys through life.

Whether your path leads you into the ocean, a lake, the mountains, the street, the desert, the sky, or just adventuring around your town, this book gives you the knowledge to get the shots you want.

This book is written for people who want to use their GoPro cameras for a variety of outdoor activities and for general use, like travelling and recording friends and family. Activities included in this book are snow sports (snowboarding and skiing), water sports (wakeboarding, kayaking, boating, surfing, and SUP'ing), air sports (hangliding and paragliding), travel (airplanes, cars, and boats) and land sports (biking, motocross, skateboarding, hiking, and rock climbing)

This easy-to-use guide will help you understand how to use your GoPro® HERO4 Black Edition camera with confidence from the initial setup, during filming and finally into an edited video clip or photo gallery.

ABOUT THE HERO4 BLACK CAMERA COVERED IN THIS BOOK

This book covers the GoPro® HERO4 Black Edition camera, which is the most advanced GoPro camera to date. The HERO4 Black Edition records 4k video at 30 frames per second, so you can produce ultra-high quality footage with the convenience of a rugged, compact GoPro camera. And the capabilities for super slow motion in HD will take your adventure to a new level of cool.

The HERO4 Black Edition includes built-in WiFi (so you can tap into the power of the GoPro App or the WiFi Remote), a flat lens port (so your photos and videos are in-focus on land and underwater) and an ultralight compact design like always.

The HERO4 Black Edition also features improved filming modes for both photo and video that put the power of creativity in your hands. The new Night Photo and Night Lapse Modes open up the possibilities for photos and videos like you have never seen produced from a GoPro camera.

The engineers at GoPro also completely redesigned the settings menus so that you can spend less time pressing buttons and more time looking up at the world around you. With the help of this book, you will get to know exactly what you need to do to capture the photos and videos you envision. So get out your HERO4 Black Edition and get ready to unlock your camera's potential.

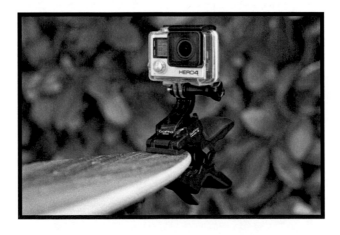

HOW TO USE THIS GUIDE

Now that you've decided to really learn how to use your GoPro® HERO4 Black Edition camera, the information in this guide will teach you everything you need to know to get the shots you've always wanted.

If you still need to learn how to use the buttons on your camera, refer to Get To Know Your HERO4 Black Edition before Step One in the beginning of this book. This section includes the essential information to familiarize you with your camera and to get you started. You can also download the HERO4 Black User Manual from GoPro's Support page on their website to be used in conjunction with the information in this guide. Your camera's User Manual tells you all of the little details about every setting option, while this guide provides you with the vital knowledge to understand what you really need to know to use your HERO4 Black Edition.

The Go Deeper sections provide more advanced tips for using your HERO4 Black camera. If you are not familiar with your camera yet, you may want to come back and read these sections after you learn the basics.

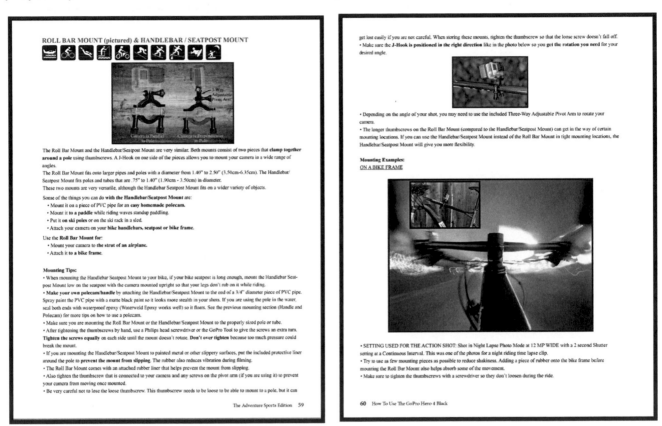

If you just bought your camera, before you buy the wrong mounts for your lifestyle, check out the Mounting Section in Step 2 to see which mounts are right for you and your passions!

Take your time, go step by step and by the time you finish this book, you will finally know how to use your GoPro® camera to record, edit and share your unique point of view!

Also, check out HowToUsePOVCameras on YouTube for video tutorials and tips.

TABLE OF CONTENTS

TABLE OF CONTENTS

GET TO KNOW YOUR HERO4 BLACK EDITION

WHAT ARE THESE BUTTONS AND PORTS FOR?

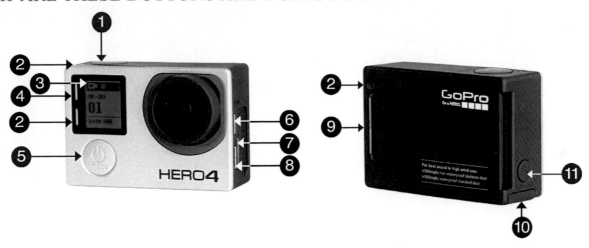

1. SHUTTER/SELECT BUTTON

Push this button to start and stop recording.

Also, when scrolling through Modes or Settings, push this button to SELECT your choices.

2. STATUS INDICATOR LIGHTS

These red lights turn on when the camera is recording video and when taking photos. You can turn off 2 or all 4 (one is on the bottom) of these lights in the Setup Menu.

3. LCD STATUS SCREEN

This screen tells you about your camera's settings. See the detailed LCD Status Screen diagram for an explanation of what this screen displays.

4. WI-FI INDICATOR LIGHT (BLUE)

This blue light flashes when your camera's Wi-Fi is enabled.

5. POWER/MODE BUTTON

Press this button to turn your camera ON.

Once your camera is powered on, press this button to change shooting modes and scroll through the Setup Menu.

Hold down this button down for 2 seconds to turn your camera OFF.

6. MICRO HDMI PORT (Cable not included)

Connect a Micro HDMI cable to this port (along with a Composite Cable) to connect your camera to a TV/HDTV.

7. MICRO SD CARD SLOT (SD card not included)

This is where you insert the Micro SD memory card to store your videos and photos.

8. MINI-USB PORT

Connect the included USB cable to this port and the USB port on your computer or USB power supply to charge the battery.

With the USB cable connected to your computer, turn your camera on to view your camera's files and transfer them to your computer. (Video and Photo files are stored in the DCIM folder on your camera's memory card) Step-by-step instructions for transferring your files are provided in Step 4- Creation.

9. HERO PORT

This port is used for connecting a Battery BacPac or LCD BacPac (both sold separately).

10. BATTERY DOOR

Slide the tab to release the battery door to install or replace the rechargeable battery.

11. SETTINGS/TAG BUTTON

Press this button to open the settings menu for the current shooting mode.

Pressing this button while recording video will add a HiLight Tag (See more about HiLight Tagging in Step 3- Capture Your Action)

You can also hold down this button to turn ON/OFF your camera's WiFi.

GET TO KNOW YOUR HERO4 BLACK EDITION

SETTING UP YOUR CAMERA FOR THE FIRST TIME

1. **Remove your camera from the Waterproof Housing**. When the camera is out of the housing, don't set the camera down on the lens.

2. **Open the Battery Door.** While you have it open, write down the serial number inside. You will need this for the update. Insert the Battery.

3. **Remove the door** that covers the USB Port, HDMI Port and Micro SD Card slot.

4. **Insert the Micro SD Card.**

5. **Charge your camera**. Plug the included USB cable into the port on your camera and connect to a computer or USB power supply. Your camera battery comes partially charged and using it with a partial charge will not affect the battery life.

6. **Update your camera's firmware.** Go to GoPro.com/Support and follow their update instructions to update the firmware on your camera. Updating your camera will ensure that your camera is equipped with the most up-to-date features and settings. You can also update your camera through GoPro Studio or wirelessly through the GoPro App.

7. After updating, put your camera **back in the Waterproof Housing**.

ABOUT THE CAMERA'S LCD STATUS SCREEN

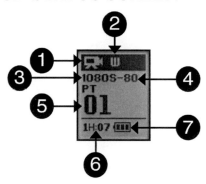

The LCD Screen tells you the following information about your camera settings, modes and status:

1. CAMERA MODE

This icon indicates if you are in Video, Photo, or Multi-Shot Mode.

2. FOV (FIELD OF VIEW)

Lets you know if you are shooting in Wide, Medium or Narrow FOV in Video Mode, or Wide or Medium FOV in Photo Modes.

3. RESOLUTION/FPS (FRAMES PER SECOND)

In Video Mode, this displays the Resolution (1080, 960, 720, etc.) and the Frame Rate (30, 48, 60, etc.).

In the Photo Modes, the Photo Resolution is displayed.

4. TIME INTERVAL SETTINGS (NOT SHOWN)

In Burst, Time Lapse, and Night Lapse Modes, this tells you how often your camera will take a photo.

5. COUNTER

In Video Mode, this tells you how many videos you have recorded. When recording, the display is a time counter showing the length of your recorded video.

In the Photo Modes, the number indicates the TOTAL number of photos you have taken.

6. TIME/STORAGE/FILES

In Video Mode, this shows you the remaining number of minutes you can record on your memory card at the current video setting. (This time will change when you change settings because different file sizes require different amounts of memory)

In Photo Modes, this will tell you how many photos you have remaining at the current setting.

7. BATTERY LIFE

This tells you if you have 1, 2, or 3 bars of Battery left.

GET TO KNOW YOUR HERO4 BLACK EDITION

NAVIGATING YOUR HERO4 BLACK

Making your way through your GoPro camera's modes and menus can be very confusing at first. But after a little practice, you will be able to get around your camera with ease. If you want to take a moment to practice getting around, follow the steps to take a short tour.

1. **Press the front Power/Mode Button to turn your camera on**. It may take up to 10 seconds for your camera to turn on.

2. Once your camera is on, **press the Power/Mode Button to scroll through the four modes** until you get back to Video Mode. The four modes are: Video, Photo, Multi-Shot, and Setup.

3. **Press the Settings/Tag Button on the left side of your camera.** This will open up the settings menu for Video Mode.

4. Within each mode, there are several Capture Modes you can choose from. **Press the top Shutter Button four times** to scroll through them and return to Video. In Video Mode, for example, there are four Capture Modes: 1) Video, 2) Time Lapse Video, 3) Vid + Photo, and 3) Looping. The next chapter will help you understand the various modes.

5. Each Capture Mode has its own settings menu. You can scroll through the settings option in this menu by **pressing the Power/Mode Button**.

6. Don't change any of the settings yet, but in the Settings Menu, **pressing the top Shutter Button changes the setting** for the highlighted setting. The **front Power/Mode Button scroll**s to the next setting option.

7. **Press the Settings/Tag Button** again to exit out of the Settings Menu.

TIP: Remember this to navigate your camera:

The front Power/Mode Button scrolls through.

The top Shutter Button selects.

The left side Settings/Tag Button opens and escapes out of the settings menu.

Go Deeper

The settings you choose in one mode will not change the settings in another mode. For example, changing the photo resolution in Photo Mode will not change the photo resolution in Multi-Shot Mode.

However, changes made will affect the settings for the other Capture Modes within the same mode. For example, if you change the video resolution in Looping Mode, it will also change the resolution in Vid + Photo Mode.

NOW THAT YOU'VE GOT YOUR CAMERA UP AND RUNNING AND YOU HAVE PRACTICED PRESSING THE BUTTONS, GO TO STEP ONE TO START LEARNING ABOUT THE MODES AND SETTINGS.

STEP ONE

THE SETTINGS

Choose Your Settings to Get The Shot

The single biggest factor to getting great shots with your GoPro® HERO4 Black Edition camera is setting up your shots correctly. Unlike traditional photography where you are following the subject looking for the image, this is more like those "camera traps" National Geographic photographers use to capture photographs of elusive wildlife drinking from a river in Africa. But with point of view cameras, you are the photographer and the lion.

Choosing the right settings with your finished product (video or photos) in mind is almost as important as the action you are recording. Unfortunately, explaining the settings is the most technical step, so once you get through this first step, the rest will be a breeze. Just try to get a basic understanding of what the settings mean and the rest should fall into place. This step gives you a rundown of which settings to choose whether you are shooting videos or photos. So, let's get into the business of having fun.

Note: If you haven't yet updated your camera or still need to learn how to use the buttons, the Get To Know Your HERO4 Black Edition section in the beginning of this book tells you about the different buttons and how to use them. Check that out first and then move on to learning the settings.

Make sure you are running the most current firmware (v02.00.00 or higher) to take advantage of the modes and settings as shown in this book.

RECORDING VIDEOS

This section will help you understand when and how to use the different modes when using your HERO4 to record videos. After learning about the four video capture modes, you will learn how to select the correct settings for the videos you are filming.

There are two things you need to do to set up your camera to record videos:

1) Choose your **Video Capture Mode**
2) Choose your **Settings**

#1- Choose your VIDEO CAPTURE MODE

VIDEO MODE

When you first turn on your camera, push the front POWER/MODE Button to Video Mode and push the top Shutter Button to select. Once you are in Video Mode, push the side Settings/Tag button to access the following four Video Capture Modes.

The four capture options in Video Mode all record video, but they offer different ways of recording. You will probably use the first two capture modes most of the time, but it is helpful to understand what the other two options are for.

Video

This is the standard video mode which you will use 99% of the time for recording video.

When you are in Video Capture Mode, your camera will just record video. Press the Shutter Button once to start recording video. Press the Shutter Button again to stop recording the clip.

Time Lapse Video

In Time Lapse Video Mode, your camera records one frame (similar to one photo) at the selected interval (.5 sec, 1 sec, etc.). The individual frames are then automatically stitched together and played back as a video at 30 frames per second. Because the frames are spaced apart and then played back quickly, there are gaps in between moments and time appears to speed up, creating the time lapse effect.

The engineers at GoPro have really tuned into the needs of their consumers with the addition of this mode to the HERO4 cameras. Although this mode lacks some of the advanced controls available in Time Lapse Photo Mode, the instant gratification of viewing your time lapses will probably make this one of your favorite video modes.

Go Deeper

Time lapses make a really artsy addition to a video. Learning the art of creating a visually-appealing time lapse takes some experimentation to get right, so don't be discouraged if you don't get a great one on your first try. **The following section will help you with some of the more technical aspects of Time Lapse Video Mode.**

• Unlike other video modes, the time counter will **display the playback duration of the video**, not the recording time. **To capture one second of video, you need to record 30 frames**. The time counter will remain at 00:01 (1 second) until you have recorded 30 frames.

The following chart tells you how long you need to record at each interval for 1 second of video:

INTERVAL (in seconds)	RECORDING TIME REQUIRED FOR A 1 SEC. CLIP
.5	15 seconds
1	30 seconds
2	1 minute
5	2.5 minutes
10	5 minutes
30	15 minutes
60	30 minutes

• Choose a **short interval** (.5, 1, 2, or 5 seconds) for a scene with **continuously moving action** like waves lapping on the beach or traffic in a city for example. A short interval is also useful for **an event that happens over a relatively short period of time**, like a sunrise or preparing your gear to go ride.

• Choose a **long interval** (10, 30 or 60 seconds) for a scene where there is **not a lot of movement**, like slow-moving clouds, or **for longer duration events**, like road trips or long art projects.

• **Advanced settings** such as Protune, Auto Low Light and Spot Meter are not available when using Time Lapse Video Mode.

• When using the LCD BacPac to record a time lapse, **the preview will be choppy**, but your final time lapse video will play back in smooth video.

• There are only **two resolutions available** in Time Lapse Video Mode: **4k** for 16:9 Widescreen shots and **2.7k 4:3** for Standard Aspect Ratio shots. You will learn about using the different aspect ratios in the next section. **Battery runtime** in Time Lapse Video Mode is similar to recording normal video in the same resolution even though you are capturing far fewer frames.

• **You can also use Time Lapse Photo Mode** to create time lapse videos. Time Lapse Photo Mode gives you more control over the appearance of your video because you can view each frame individually and batch process them with photo-editing software. When using **Time Lapse Video Mode, you do not have access to the individual frames**. You will learn more about creating a time lapse from photos in the Time Lapse Photo Mode section.

For more tips on setting up and filming time lapses, see Step 6- More Time Lapse Tips.

 Vid & Photo

In this mode, your camera takes a photo every 5, 10, 30, or 60 seconds WHILE you are recording video.

But, you do not really ever need to use this mode because the photos taken in this mode look exactly like a photo taken from a video clip. You can minimize the amount of files you need to organize and edit by recording in Video Capture Mode and extracting a frame grab (still photo) during editing. (You will learn how to extract a Frame Grab in Step 4-Editing)

However, Vid and Photo mode is convenient if you want instant photos of your video to send from the GoPro App without opening the video file.

Go Deeper

When you are in a Widescreen 16:9 Aspect Ratio video setting (1080-24, 1080-30, 720-60, 720-30), the camera will take widescreen 8mp photos. When you are shooting at 1440-24 video resolution, you will get 12mp photos.

Vid & Photo Mode only has the following settings available in the Settings Menu: 1440-24, 1080-24, 1080-30, 720-30, or 720-60.

> **T**IP: When you are in any of the Video Modes, you can take a photo anytime while videoing by pressing the front Power/Mode button. This will not interrupt the video clip. This Photo-In-Video option is only compatible with the following resolutions: 1440-24, 1080-24, 1080-30, or 720-30.

 Looping

In Looping Mode, the video keeps recording over itself until you stop recording. You can select the looping interval in the settings menu. The available looping intervals are 5, 20, 60 and 120 minutes as long as you have enough available space on your camera's memory card.

After your camera has recorded the selected amount of time, it will begin to overwrite (delete) the previous video. This mode works well for endless amounts of video where nothing is really happening, but you want to record continuously in case something does happen.

This mode is useful if you are using your camera as a dashboard camera in your vehicle or as a security camera. Push the Shutter Button to stop recording when something happens and you will have the most recent video available to review.

#2- Choose your SETTINGS

There are three things you should understand when choosing your video settings and we will walk you through each one:

A) Understand what **File Size** means
B) Choose the **Aspect Ratio**
C) **Select a setting** based on the type of action you are filming

A) Understand what FILE SIZE means

When deciding which settings to choose, you will see the file size displayed like this: 1080-30, which is also sometimes written like this: 1080p @ 30FPS.

What does this mean? This refers to two things:

 1) RESOLUTION

In simple terms, a pixel is a small dot that makes up the image. The number before the P (which stands for "progressive scan", which, without getting too technical, creates smoother, more detailed video) defines how many pixels (or dots) there are in the vertical height of the image. More pixels make a larger image and create more detail which produces a higher quality image.

The number **1080** in the example refers to the vertical height of the image being recorded. In other words, the image is 1,080 pixels high. The higher the number, the better the quality.

There is also another number that defines the width of the image in pixels, but this number is not shown in the settings. It's kind of a silent number, but it exists and it defines the width of the image recorded. When referring to the screen resolution, it's written out like this- **1920**x1080P.

*With 4k and 2.7k, the names represent the width of the image, not the height.

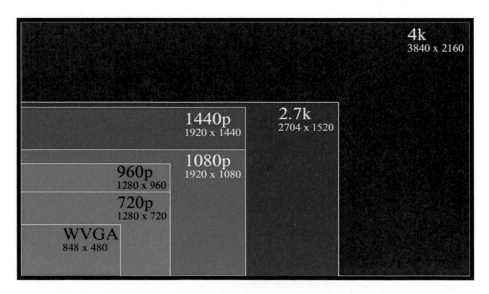

This chart shows the relative pixel dimensions of the different file sizes.

▉ 2) FRAMES PER SECOND (FPS)

The number after the dash (30 in this example) tells you how many frames are being recorded each second. **Frames Per Second (FPS)** refers to the number of individual frames (similar to photos) the camera records each second.

Capturing footage at a higher frame rate (higher number FPS) is better if you are planning to play back your footage in slow-mo, which a lot of action clips need to look good. All of the video frame rates play back at regular speed by default. Slow motion is created when you change the rate at which the frames of a video are viewed. For example, if you record a 1 second clip at 60 frames per second, and you play it back at only 24 frames per second, it will take you 2.5 seconds to watch that 1 second clip. This effectively makes your video show in slow motion.

Recording more frames per second (a higher FPS) gives you the ability to slow down the footage from a high frame rate, such as 120, 60 or 48FPS, to a slower frame rate, such as 24FPS, and still have that smooth film look.

Many film and video makers display their footage at 24FPS because the on-screen "look" most closely matches film. Other professional video producers use 30FPS as a standard frame rate, arguing that 24FPS is only useful if you are transferring digital footage to film, which never really happens. 30 frames per second is better suited for viewing on televisions and computers. However, because it is a debatable topic and you can get "slower" slow motion at 24 frames per second, **this book uses 24 frames per second as a standard**.

B) Choose your ASPECT RATIO - 16:9 Widescreen <u>OR</u> 4:3 Standard

WHAT IS AN ASPECT RATIO?

The Aspect Ratio (16:9 or 4:3) refers to the ratio (width:height) of the image you will capture. There are **two standard ratios you should choose from**:

16:9 Widescreen Aspect Ratio

• **16:9 Widescreen** is a widescreen format for HDTV's, plasma widescreen TV's, and cinema screens. YouTube, Vimeo and Hulu support this ratio. The benefit of using this ratio gives your footage the cool **widescreen cinematic look**. The Widescreen ratio also offers **faster frame rates** to create smoother slow motion. Widescreen is the **best choice for most shots when you have enough distance to capture what you want in the frame**. 4k, 2.7k, 1080p, 720p and WVGA are all 16:9 Widescreen resolutions.
*SuperView resolutions play in 16:9 Widescreen.

4:3 Standard Aspect Ratio

• **4:3 Standard** was the "default" ratio all videos used to be before widescreen came around. YouTube, Vimeo and Hulu also support this ratio, but you will see black bars on the sides so that the video fits in the widescreen player. The benefit of using a 4:3 ratio is that you get the **widest top-to-bottom viewing area**. This makes it **easier to get your entire body in the shot**, especially when you are shooting at a close angle or when your camera is mounted on your body or equipment. 4:3 resolutions are the **best choice for POV shots when your camera is mounted close to you**. 2.7k 4:3, 1440p and 960p are 4:3 Standard resolutions.
*SuperView captures the full frame of a 4:3 Standard Aspect Ratio.

*The diagram below shows how the **Widescreen 16:9** shot in the middle crops out the top and bottom of what's captured in the **Standard 4:3** frame.*

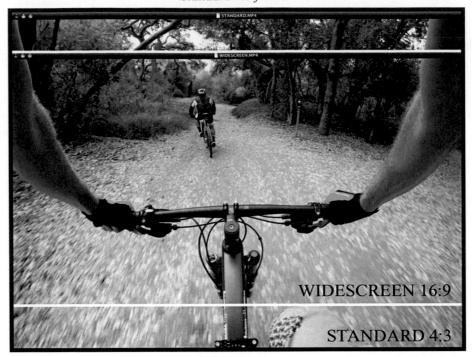

*Compare the **Widescreen 16:9 Aspect Ratio** frame grab in the middle (taken at 1080p @ 60fps WIDE) with the **Standard 4:3 Aspect Ratio** frame grab (taken at 1440p @ 60fps WIDE). Both were taken with the HERO4 Black camera in Video Capture Mode.*

TIP: Since you will most likely want to display your footage in a 16:9 Widescreen Aspect Ratio, any footage filmed in a 4:3 Aspect Ratio will need to be edited to fit a widescreen frame. If you need to film in a 4:3 Aspect Ratio for a particular scene, you can crop or scale it when editing to make it match (We will get to that in Step 4-Creation)

C) Select a setting based on the type of action you are filming

Video settings are changed by pressing the Settings/Tag Button on the left side of your camera when you are in Video Mode. You can select the right settings for your shot by changing Resolution and FPS. Changing the Field of View (FOV) for your shot will also make a big difference, which you will learn about soon in Other Useful Video Setting Options.

When choosing settings for a particular activity, consider the following tips:

TIP #1: Use the highest resolution that suits your needs. It's always better to reduce a file size rather than increase it.

TIP #2: If you are shooting in the Standard 4:3 Aspect Ratio and plan to crop your video to Widescreen 16:9 during editing, 1440p crops to 1080p and 960p crops to 720p without losing quality.

TIP #3: Changing the frame rate during editing will also affect the audio speed. Just because you record at a faster frame rate, doesn't mean you have to use the clip for slow motion. You can play a clip recorded at any frame rate in regular motion video. If you record a video clip at 30FPS and you want to play it at regular speed, when you export it to 24FPS, the extra 6 frames will be removed without affecting the audio.

PAL vs. NTSC: Most countries outside of North America use a format called PAL instead of NTSC. If you are in a country that uses PAL and your camera is set to shoot at PAL, the available frames per second rate will be different while using certain settings. Users in PAL countries often get confused because some of the NTSC frame rates are not available in the video settings menu. The PAL frame rates that differ from the NTSC frame rates are noted below.

NTSC (IN FRAMES PER SECOND)	PAL (IN FRAMES PER SECOND)
30	25
48	50 (for 2.7k only)
60	50

USE THIS SIMPLIFIED LIST OF THE MOST USEFUL SETTINGS TO CHOOSE YOUR SETTING BASED ON WHAT YOU ARE FILMING:

RECOMMENDED SETTINGS FOR THE HERO4 BLACK EDITION

16:9 (Widescreen) Video Modes

If you choose a 16:9 widescreen aspect ratio, here are the 4 settings you will need and what they are useful for:

A) FOR REGULAR SPEED 4k or 1080p PLAYBACK, CHOOSE 4k @ 30FPS (4k-30)

• 30 frames per second means you can play your footage at **regular speed in full 4k resolution or downsize to 2.7k or 1080p.**

• If you are editing a **4k video clip**, this is the resolution to use for the majority of your shots. 4k SuperView-24 is the other 4k option if you need a wider field of view. For more about recording, editing and viewing 4k, see the 4k section in Step 6- Beyond the Basics.

• If you are **downsizing your footage to 1080 hd**, you can zoom in 200% and still maintain full 1080 hd resolution. The 4k resolution gives you the **ability to crop, reframe or stabilize your footage** during editing and still maintain high-quality 1080p footage.

B) FOR SLOW MOTION 1080p PLAYBACK, CHOOSE 1080p @ 60FPS (1080-60)

• 60 frames per second means you can DRAMATICALLY slow down the footage 2.5x to 24 frames per second and have really smooth (not choppy) slow motion.

• The 2.7k resolution gives you enough extra space to zoom in 141% and still maintain full 1080 hd resolution. The extra resolution gives you the **ability to crop, reframe or stabilize your footage** during editing and still maintain high-quality 1080 hd clips.

• This is the **most useful all-around setting for general action** filming because you can achieve high quality slow motion, but it does not put as much strain on your camera as 1080p-120.

C) FOR SUPER SLOW MOTION 1080p PLAYBACK, CHOOSE 1080p @ 120FPS (1080-120)

• 120 frames per second means you can DRAMATICALLY slow down the footage 5x to 24 frames per second and have really smooth (not choppy) super slow motion.• Screen Resolution is 848 pixels wide x 480 pixels high.

• This setting is ideal for **fast action sports in bright daylight** where you want to play back your footage in the highest quality slow motion possible.

RECOMMENDED SETTINGS FOR THE HERO4 BLACK EDITION

16:9 (Widescreen) Video Modes (cont.)

*D) FOR **SUPER, SUPER SLOW MOTION** PLAYBACK FOR WEB OR SOCIAL MEDIA CONTENT, CHOOSE <u>WVGA @ 240FPS (WVGA-240)</u>*

• 240 Frames per second means you can DRAMATICALLY slow down the footage 10x to 24 frames per second and have really smooth (not choppy) super slow motion.

• The lower resolution is **good for web content** or exporting to Instagram, but quality is much lower than 1080p or 720p. It is ideal if you need SUPER SLOW MOTION and can sacrifice some quality.

• If you are filming 240FPS for slow motion and the Narrow Field of View works for your shot, choose **720p-240 Narrow** for a higher resolution option. You will learn about the different fields of view after the SuperView section.

4:3 (Standard) Video Modes

As mentioned before, the 4:3 Aspect Ratio is especially useful for body-mounted shots where your camera is mounted close to you and you need the full top-to-bottom height of the image.

If you choose a 4:3 standard aspect ratio, here are the 3 settings you will need:

*A) FOR **REGULAR SPEED** PLAYBACK, CHOOSE <u>2.7k 4:3 @ 30FPS (2.7k 4:3-30)</u>*

• 30 frames per second means you can play your footage at regular speed. You can also slightly slow down the footage to 24 frames per second and still have really smooth (not choppy) video.

• The 2.7k resolution gives you enough extra space to zoom in 141% and still maintain full 1080 hd resolution. The extra resolution gives you the ability to crop, reframe or stabilize your footage during editing and still maintain high-quality 1080 hd clips.

• This setting is ideal **when you need the full top-to-bottom view**, but it is **not ideal for high action sports** because of the low frame rate.

*B) FOR **SLOW MOTION** PLAYBACK, CHOOSE <u>1440p @ 80FPS (1440-80)</u>*

• 80 frames per second means you can DRAMATICALLY slow down the footage 3.3x to 24 frames per second and have really smooth (not choppy) slow motion.

• This setting is ideal for **high-speed action sports when you need to use a 4:3 Aspect Ratio** to get the shot you want. It can be scaled or cropped to full 1080 hd resolution when you edit.

*C) FOR **SUPER SLOW MOTION**, CHOOSE <u>960p @ 120FPS (960-120)</u>*

• 120 Frames per second means you can DRAMATICALLY slow down the footage 5x to 24 frames per second and have really smooth (not choppy) super slow motion.

• If you need the extra frames per second for super slow motion, this is the 4:3 setting to use to get the shot. 960 can be scaled or stretch to match 720 hd without losing resolution.

OTHER USEFUL VIDEO SETTING OPTIONS

To keep the learning process as simple as possible, only the most useful video options are included here. Refer to the User Manual for any settings not shown here.

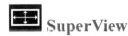 **SuperView**

SuperView is one of the options in Video Resolutions and can be shot at 4k (at 24FPS), 2.7k (at 30FPS), 1080p or 720p. An "S" next to the video resolution indicates a Superview setting.

GoPro calls SuperView "the world's most immersive wide angle perspective" because it **captures the top to bottom field of view of a Standard 4:3 Aspect Ratio but displays it as a Widescreen shot**. This is great for **up close or body-mounted shots** where you cannot get the entire subject in the frame. **Be aware that there is distortion around the edges of the frame** when shooting in SuperView because the camera is using framing adjustments to transform a video captured in Standard 4:3 Aspect Ratio into a Widescreen 16:9 shot. SuperView is **best for shots with the subject centered in the frame**, like surfing or biking.

If you record a video clip in a 4:3 aspect ratio (2.7k 4:3, 1440p or 960p) and decide you want to convert the clip to Widescreen 16:9 during editing, you can get a similar effect to SuperView by using one of the GoPro Presets. You will learn how to do that in Step 4- Editing Your Video.

The following are the most useful SuperView resolutions:
• *4kS-24*: SuperView in full 4k resolution. Because of the low frame rate, this resolution is perfect for shots where your camera is mounted in a stable position to eliminate shake. This setting is great for **scenic shots and panoramas** that won't be affected by the distortion around the sides of the frame. This also the 4k setting to use for **body-mounted shots in bright light** that do not require slow motion playback.

• *2.7kS-30*: This resolution doesn't allow for slow motion, but 2.7k gives you the ability to zoom in to reduce some of the distortion if you need to when editing for a 1080 Widescreen video clip. Best for shots with your **camera mounted on a tripod or in a stable position**.

• *1080S-80 or 60*: Choose 80FPS if you want maximum slow motion in this resolution. Perfect for **body-mounted shots and full action shots** because the high frame rate allows for super high quality slow motion.

• *720S-120*: If you want the extra frame rates, this is the go-to for **maximum slow-motion**, although you sacrifice some quality in the resolution.

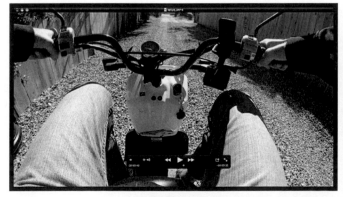 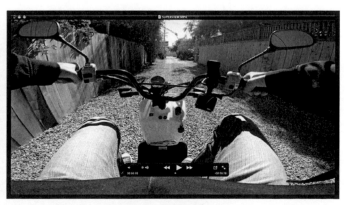

The frame grab on the left was filmed on the HERO4 Black Edition at 4k WIDE.
The video on the right was filmed in 4k SuperView. Notice how you can see the rear view mirrors in the SuperView frame.

FOV Wide, Medium, or Narrow Field of View (FOV)

In Video Mode, press the Settings/Tag Button to access the settings menu. The field of view can be changed in the Video Settings menu below the frame rate setting. Changing the field of view is similar to changing lenses.

• **Wide** (Called Ultra Wide in the User's Manual) Field of View captures the widest field of view and is equivalent to a 14mm lens.

• **Medium** Field of View captures a narrower field of view equivalent to a 21mm lens.

• **Narrow** Field of View captures the narrowest field of view which is equivalent to a 28mm lens.

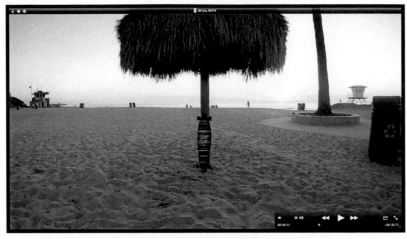

WIDE FOV

MEDIUM FOV

NARROW FOV

• **"Wide"** is the default lens mode and is the mode you will need **most often for self-portrait action shots when the camera is mounted on you or close to you**. See "Get To Know Your Lens" in Step 3 for more tips on how to get the best shots with the wide-angle lens. Wide FOV is available in all of the resolutions.

• If you know you are going to be far from your subject, you can choose to use "Medium" Field of View to get a little closer or to minimize distortion. The Medium FOV option is available in the following 16:9 Widescreen resolutions: 2.7k, 1080p (24FPS-60FPS), and 720p resolutions. If you want to film in Medium FOV, **2.7k-48 Medium is the best choice** for most shots, or you can use **1080p-60 Medium if you want a higher frame rate** for slow motion.

• Use the **"Narrow"** mode for **everyday shooting to reduce the distorted fisheye effect**. The Narrow Video mode works like a standard 28mm lens. The Narrow FOV is available in all of the 1080p and 720p 16:9 Widescreen resolutions. **1080p-60 Narrow is the most useful setting when shooting in Narrow FOV. 720p-240 Narrow is a great option for super slow motion action shots.**

Auto Low Light

Auto Low Light is only available for slow motion frame rates (48 FPS – 120 FPS). Typically, it's better to **choose a lower frame rate** (24 or 30 FPS) in the settings menu when you will be shooting **in a low light situation** and **choose a slow motion frame rate (60-240 FPS) during bright daylight**. This gives you better control of your footage.

Go Deeper
When Auto Low Light is turned on, your camera will automatically shift to a lower frame rate in low light situations. For example, if you are recording at 48 FPS, Auto Low Light will force your camera to record at 24 FPS in low light situations to allow your camera to take in more light.

TAKING PHOTOS

The HERO4 Black Edition offers a wide variety of photo modes to help you achieve some amazing photos. Because of the versatility of GoPro cameras, there are a variety of ways you can set up your camera to take photos, from taking a single photo to taking a speedy burst of 30 photos in one second. The photo-taking capability of this camera is top-notch, and that is great motivation to understand the various shooting modes.

This section will help you understand when and how to use the different modes when using your HERO4 to take photos. After learning about the different photo modes, you will learn how to select the correct settings for the photos you are taking.

There are two things you need to do to set up your camera to take photos:

1) Choose your Shooting Mode
2) Choose your File Size

#1- Choose your SHOOTING MODE

When you turn your camera on and scroll through the modes, there are two modes on the main menu that are designated to taking photos- Photo Mode and Multi-Shot Mode. Within both of these modes, there are also several Capture Modes to choose from.

PHOTO MODE

For the most part, the Capture Modes within Photo Mode are designed for you to operate your HERO4 like a standard point and shoot camera, where pushing the Shutter Button tells your camera to take a photo.

When you first turn on your camera, push the front POWER/MODE Button to Photo Mode and press the top Shutter Button to select. Once you are in Photo Mode, push the side Settings/Tag button to access the following three Capture Modes.

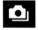 A) **Single Photo**- Scenic Photos or Portraits

Photo taken with the HERO4 Black camera at 12 MP WIDE in Single Photo Mode. The camera was handheld.

This mode takes one photo per push of the Shutter Button. **Best for shots that don't involve high action**, like a scenic photo or portrait.

When taking photos in Single Photo Mode, hold your camera steady and keep your subject around the middle of the frame for the least distortion. You can also rotate your camera 90 degrees to take vertical photos.

You camera will take the photo immediately after you press the Shutter Button.

B) **Continuous Photo**

In Continuous Photo Mode, you can set your camera to take a photo burst of up to 10 photos per second for as long as you hold down the shutter button. Use this mode when you need **a fast sequence of photos that lasts longer than a few seconds** and you have a free hand to hold down the Shutter Button.

The drawback of this mode is that you need to press and hold down the Shutter Button to take photos so you need to have a free hand. Continuous Photo Mode works also works with the GoPro App and with GoPro's Smart WiFi Remote. Continuous Photo Mode will not work with the original WiFi Remote.

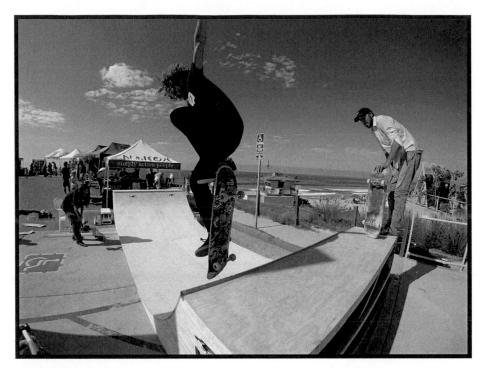

Photo taken with the HERO4 Black camera at 12 MP WIDE in Continuous Photo Mode at 10 photos per second using the Smart WiFi Remote. The camera was mounted upright on a polecam as shown in Step 2.

Some of the Multi-Shot Modes (which you will learn about next), like Burst Mode and Time Lapse Mode are more convenient to use because they only require one push of the Shutter Button. For a shorter sequence up to 30 photos, you can use Burst Mode. If you don't need so many photos per second, Time Lapse Mode does not require you to hold down the Shutter Button.

C) **Night Photo**

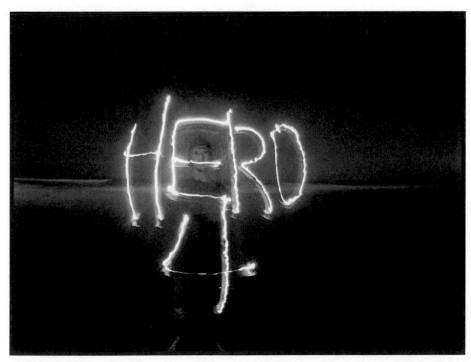

Photo taken with the HERO4 Black camera at 12 MP WIDE in Night Photo Mode with a Shutter Time of 30 seconds. The camera was set up on a tripod using the Tripod Mount. See Light Painting below for tips on how to capture this effect.

One of the biggest improvements in the current HERO4 cameras is the ability to take **long exposure photos**. This mode is called Night Photo and it allows you to set your camera's shutter to stay open for 2-30 seconds. The long exposure, as it is called, allows light to slowly "write" an image in low light situations. Long exposure photos can be taken at dawn or dusk (up until about 30 minutes before sunrise or after sunset) or nighttime with your camera mounted in a stationary position.

Go Deeper

Night Photo Mode opens up a new realm of possibilities for night shots, especially when combined with Night Lapse Mode, which enables you to take a series of long exposure photos in sequence. Long exposure photos can look stunning, but taking them is an art in itself. **The following tips will help you capture the night photo you envision**.

• When photographing a night photo, remember that any incoming light that lands on your camera's sensor will leave its imprint. If the shutter is open for 30 seconds and you are photographing **stars with no ambient light, 30 seconds** will be just enough time to be able to see the stars.

• If you are riding your bike around the city at night, 30 seconds of city lights will leave too much of an imprint and create a blown-out background. A **shorter shutter time works better for night shots with ambient or city lights**.

• Enter the Settings Menu to select an appropriate Shutter time for your shot. The following ideas give you a starting point for choosing the Shutter time depending on your scene.

> **Auto (up to 2 seconds)-** Best for times when there is still ambient light in the sky, for example **around sunset or just before sunrise.**

> **2 sec-** Up until about **30 minutes before sunrise or 30 minutes after sunset. Night driving in a semi-urban setting** at this setting will produce great streaks of light as you pass by lights and other vehicles.

> **5 sec-** When there is a **decent amount of ambient light**, like from a busy city scene or at an amusement park. **Driving in a rural setting** with occasional passing cars.

> **10 sec or 15 sec-** A **small urban scene** where there is not too much light from building and street lights.

> **20 sec-** Dark night sky with **some ambient light** reflecting off trees or clouds.

> **30 sec-** Completely **dark night sky** like if you were out camping or away from any city lights.

• The LED lights on your camera will not flash until AFTER the photo is taken, so the **red LED light does not need to be turned off**.

• **Keep your camera still while the shutter is open**. In Night Photo mode, there is a **2 second delay** between when you push the shutter button and when your camera's shutter opens to take the photo. This delay prevents camera shake from pushing the button. However, your camera needs to be still while "writing" the photo. **Mount your camera on a tripod or in a stable position** with another mount. Moving the camera while the shutter is open will result in blurred photos.

• You can **mount your camera to a moving object** (like a bike, car, motorcycle, etc) as long as your camera is securely mounted and you can see the object in the foreground. This will give your photo a focal point, while the surrounding objects will create blurred streaks of light.

• **Light painting** is a cool effect you can do with a long exposure photograph. Find a dark place to shoot your photo. Mount your camera so it will not move while the shutter is open. Depending on how much ambient light is around you, set your camera shutter to 10, 20, or 30 seconds. After you press the shutter button, use a candle, lighter or sparkler to write something in the sky. If you are writing words, you have to write backwards (so the words read correctly in the photo) and imagine where you are writing. Anywhere you move the bright light will leave its imprint in the photo- kind of like painting with light!
If you find it too hard to write backwards, you can flip the photo during editing, but make sure there are no other words on your clothing or in the background because they will read backwards.

Using Auto White Balance for night shots will often result in inconsistent color tones. To get a realistic looking bluish hue **in a dark night scene**, turn on Protune and set the **White Balance to 3000k**. A higher number white balance (6500k) will give your photos a reddish hue. Remember to set your White Balance back to Auto for normal daylight filming.

The photo on the left was taken at 3000k White Balance. The photo on the right was taken at 6500k White Balance. The camera was mounted on a tripod for both photos.

MULTI-SHOT MODE

The three Capture Modes within Multi-Shot Mode offer creative ways to capture amazing action photos and to take photos that can be edited into a time lapse video.

If you are shooting Multi-Shot photos in low light, many will come out blurry. Usually you can pick out the best ones and come up with some usable photos. It is best, however, to shoot Multi-Shot photos in bright daylight to give your camera enough light to produce in-focus photos. If you are filming in cloudy or shady conditions, video is a better option for low light conditions.

Once you are in Multi-Shot Mode, push the side Settings/Tag button to access the following three Capture Modes.

 A) **Burst**- High Action Sports, Handheld Shots, Action Sequences

Burst Mode is **great for high action** where timing is everything. Use this mode when shooting high action sports and choose the winning shot later. You won't miss a moment. This mode is best used when holding your camera or if you are using the Smart WiFi remote, you can push the shutter button on the remote and get photos of yourself at just the right moment.

Burst Mode photos can also be used to make an action sequence, where there are multiple photos of one subject edited into a single frame. Combining the multiple images is not done automatically in the camera, but you can do this with photo-editing software (See Step 4- Editing an Action Sequence).

The HERO4 Black Edition shoots up to 30 photos in one second in this mode. You can also space out the 30 photo burst over 3 or 6 seconds, which is more useful for most action sports.

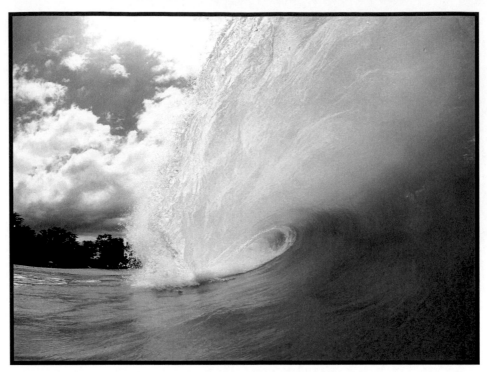

Photo taken with the HERO4 Black camera at 12 MP WIDE in Photo Burst Mode at 30 photos over 2 seconds. The camera was mounted upright on GoPole's Bobber Handle.

B) **Time Lapse**- Artsy Video Clips, Action Photos while Mounted, Self-Timer Portrait Photos

Photo taken with the HERO4 Black camera at 12 MP WIDE in Time Lapse Mode with one photo every 2 seconds. The camera was mounted upside down to a branch using the Jaws Flex Clamp.

In time lapse mode, you can set the time interval between photos and the camera will **continue shooting automatically** until you push the shutter button again (or your memory card fills up). The camera takes a sequence of photos at whatever time interval you set it to.

There are three things the Time Lapse Mode is really useful for:

1) Use Time Lapse Mode to **create a time lapse video**. A batch of photos taken sequentially in Time Lapse Mode can be easily edited together to create a time lapse video. (You will learn how to edit a time lapse video clip from photos in Step 4-Creation.)

There are several benefits of using Time Lapse Photo Mode instead of the automated Time Lapse Video Mode. One benefit is that Time Lapse Photo Mode **creates an individual photo file for each frame**. These photos can be batch processed using photo-editing software, or you can easily extract single photos from the batch. Also, the photo mode uses the full sensor so you can capture 4k files at a Standard Aspect Ratio, giving you **more flexibility to zoom in** or stretch to a Widescreen Aspect Ratio, creating a SuperView effect.

Also, once you become familiar with the advanced settings of your camera, you can **access the full range of Protune settings** for extra control over the appearance of your images.

Since the battery will run out after a couple hours max, you will need extra batteries or an external power supply for longer interval time lapses. When your camera is mounted in the Frame, you can connect to external power without moving your angle. (Learn more about the Frame in Step 2- Mounting)

INTERVAL (in seconds)	RECORDING TIME REQUIRED FOR A 30 SEC. CLIP @ 24 FPS
.5	6 minutes
1	12 minutes
2	24 minutes
5	1 hour
10	2 hours
30	6 hours
60	12 hours

Refer to this chart when planning out your Time Lapses for video. Since the battery will run out after a couple hours max, you will need extra batteries or an external power supply for longer interval time lapses. When your camera is mounted in the Frame, you can connect to external power without moving your angle. (Learn more about the Frame in Step 2- Mounting)

TIP: If a 4k time lapse video is your desired output, take photos at 12MP Wide, but if you plan to edit a 1080p video, you can reduce the photo file size to 7MP Wide or Medium depending on your shot. This will save space on your memory card and will require less computer memory for editing.

2) Use Time Lapse Mode to **shoot photos of yourself in action** by setting the interval and pushing the "shutter" button before you want to start recording and turn it off after.

• For *sports where the action happens in short bursts*, you will want to shoot at the *shortest interval possible* (.5 or 1 second) so you don't miss the best moments.

• For sports *where the action doesn't come in such short spurts*, like snowkiting/kitesurfing, windsurfing, biking or canoeing, you might want to use a *slightly longer interval* (5 or 10 seconds).

Photo taken with the HERO4 Black camera at 12 MP WIDE in Time Lapse Mode with one photo every 1 second. The camera was mounted upside down on the Chesty.

3) Since the HERO4 Black camera doesn't have a self-timer mode built-in, you can use Time Lapse Mode to capture self-portrait photos of you or a group. Set your camera up for the shot you want, push the shutter, step into the frame and keep the good photo out of the bunch. For more time lapse tips and ideas, see the time lapse section in Step 6- Beyond the Basics!

C) **Night Lapse**- Time Lapse Videos of a Night Scene, such as a city buzzing by or clouds moving through a starry sky.

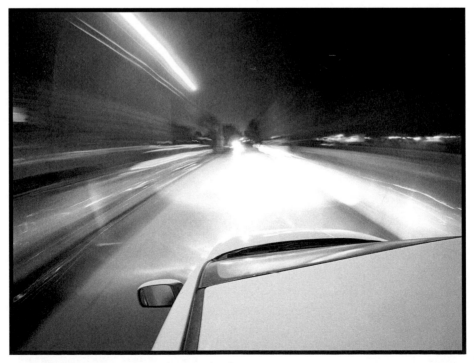

Photo Taken with the HERO4 Black camera at 12 MP WIDE in Night Lapse Mode with a 5 second Shutter at Continuous intervals. The camera was mounted to roof racks on a car using the Jaws: Flex Clamp.

A night lapse is simply a series of night photos taken in sequence which can then be combined during editing into a video clip.

When you are in Night Lapse Capture Mode, you can set the intervals by pushing the Settings/Tag Button and changing the interval time.

Refer to the tips in Night Photo Mode to determine the right Shutter time for your shot. If possible, test your shutter setting with one photo and preview it with the GoPro App on your phone or the LCD BacPac before you record an entire night of time lapse photos.

The Interval setting defines the amount of time between when one photo finishes and the next photo begins. The interval options for night lapse photos range from Continuous up to 60 minutes between photos. If you choose Continuous Interval, your camera will automatically take the next photo as soon as the prior photo is taken. For most circumstances, choose a shorter interval, such as Continuous up to 2 minutes, so you capture enough photos to put together a night lapse video. There are very limited uses for the longer intervals (30 min or 60 min) since you will only end up with a few photos over a long period of time.

Many night lapses require more time and power because each photo takes longer to capture than daytime photos. For maximum shooting time, use a USB cable to connect your camera to an external power source like a laptop or a portable phone charger.

#2- Choose your FILE SIZE

 ### Which File Size Should You Use? 12MP, 7MP, or 5MP

The settings for shooting photos are more straightforward than video. The HERO4 Black Edition shoots JPEGs, which take very little memory compared to a RAW file (like a DSLR is capable of shooting). A 16GB Sd card can store more than 2500 Jpegs at 12MP for example. For this reason, unless you are extremely low on memory, you should **take photos at the maximum resolution available which is 12 MP Wide**. You can crop or downsize from the full size 12 MP image to achieve the lower resolution images. When taking photos for a time lapse video, 12 MP photos can be combined to make a 4k video clip.

 ### Wide OR Medium Field of View

There are two fields of view to choose from in Photo Modes- Wide and Medium. Photos taken in photo modes are always captured at a 4:3 ratio.

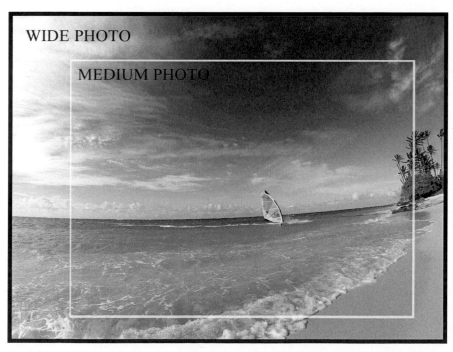

The Medium FOV Photo captures a cropped frame of the full size Wide FOV image. The camera was handheld on the 3-Way.

• **Wide** Field of View is the default which is equivalent to a 14mm lens and captures 150 degrees of angle.

• **Medium** Field of View is equivalent to a 21mm lens and captures a narrower 115 degrees of angle.

• As you can see in the example, the Medium FOV is just a cropped portion of the full size 12MP Wide photo. It is almost **always better to capture the images at the "Wide" Angle** and crop out unwanted parts of the photo later. (We will get to that in Step 4-Creation)

• If you know you are going to be far from your subject, you can choose to use "Medium" to make the object appear closer without having to crop the photo later during editing.

ADVANCED VIDEO & PHOTO SETTING OPTIONS

After you familiarize yourself with your new camera and become comfortable with the basic operations, you may want to utilize the following setting options for specific shooting needs. The following setting options can be utilized when recording videos or photos.

Spot Meter

• When Spot Meter is turned on, your camera will adjust the exposure based on the center of the frame, rather than looking at the overall scene. The effects can be more or less dramatic depending on the contrast between your foreground and background lighting. Spot Meter will not even out the contrast between the foreground and background, but it will take a correct exposure reading for the center of the frame.

Spot Meter is particularly effective if your subject appears dark in front of a bright background. When Spot Meter is turned on, make sure your subject is centered in the frame to get a correct exposure reading. Moving your subject out of the center of the frame will quickly affect the exposure. Spot Meter is best used when your camera is mounted on a tripod and your subject is going to remain in the center of the frame for the duration of the clip.

Protune

• Protune is a setting that affects video and photo quality. It is mostly aimed towards experienced image makers who want more control over the look of the footage in post-production (editing). You can reap the benefits of it by editing your footage in GoPro Studio (which we will get into in Step 4).

• With the HERO4, Protune affects both photo and video quality. Protune can be turned on in one mode and off in another simultaneously.

Go Deeper

Advanced Protune Settings

If you choose to use Protune, you can customize the Protune Controls. After you turn on Protune in the Settings menu, the following setting options will appear below Protune in the Setting menu: White Balance, Color, ISO Limit, Sharpness and Exposure Value Compensation. You can customize these settings to your particular tastes. Changing the Protune settings can help you capture high quality footage with low noise. This footage will need post production (editing) to get the colors and look you want.

If you decide you want to turn Protune on once you get comfortable with your camera, you can start with the **following recommended settings**:

 White Balance : Auto

White balance refers to the color temperature- a lower number creates a colder (bluish) look and a higher number creates a warmer (more yellowish) tone. Unless you have experience setting white balance, or have a very specific need, Auto White Balance is your best option. The exception is when you are taking a Night Photo in a dark night sky: you can set the White Balance to 3000K to achieve a realistic-looking night sky.

 Color : GoPro Color

GoPro Color adjusts colors to add vibrance and give your photos pop, just like when Protune is turned off. Flat will produce photos and videos without as much color, but it does pick up more details in the shadows and highlights. If you use Flat, you will need to adjust the colors in post-production.

 ISO Limit: 1600 for Video / 400 for Photo

A higher ISO records light more quickly, so it is better for low light, but the tradeoff is a lot of noise in your video or photos. Noise is all of those little specks that make your footage look grainy like you may have noticed in videos you've recorded at night. If you record at a lower ISO, you can reduce the noise and brighten up any dark footage during editing.

 Sharpness: Medium

Sharpness refers to the amount of digital sharpness that is added to your footage in the camera after it is shot. A medium amount of sharpness will make your footage look crisp, but not overly sharpened.

 Exposure Value Compensation: 0

EV Comp tells your camera to make the footage brighter or darker than the exposure reading from the camera. You only need to adjust this manually if you are going for an overexposed or underexposed look, or if your camera is taking an inaccurate reading of a scene and you want to manually adjust the exposure.

SETUP MENU

The last of the four main modes is Setup Mode. Setup Mode allows you to change various settings on your camera.

After powering on your camera, press the front Power/Mode Button three times to reach the Setup Menu. Press the top Shutter Button to enter the menu. The following items can be set when you enter Setup Mode.

You can come back to revisit most of these settings once you are comfortable using your camera.

Two of the settings, Date and PAL/NTSC, should be checked now, but the rest can wait until you begin using your camera. If you have not done so yet, **start by setting the date** so you can keep your files organized. Also, if you are outside of North America, check to see if your camera is set to PAL or NTSC.

 Wireless

You can connect to the WiFi Remote or GoPro App through the wireless dialog. Once you connect to a remote or the App, you can also turn on and off the camera's WiFi signal by holding down the Settings/Tag button on the left side of your camera. The Settings/Tag button can enable or disable the WiFi when your camera is on of off.

A **flashing blue light** on the front of your camera **means WiFi is enabled**. You will also see a WiFi symbol next to the Battery Life symbol.

To turn off your camera's WiFi signal, hold down the WiFi On/Off button on the left side of your camera. The blue light will flash 7 times and the WiFi signal will turn off. The blue WiFi light will stop flashing.

You do not need to have your camera's WiFi enabled to use your camera or be within range of any external WiFi signal. The WiFi is an added feature to connect to the WiFi Remote or the GoPro App on a smartphone. The WiFi connection between your camera and the WiFi remote or GoPro App does not require any external WiFi signal. The camera and remote/phone communicate with each other.

↑↓ Up Down

With this setting, you can tell the camera which way is up or down so that it records in the correct orientation. This can be really useful when mounting your camera upside down using some of the mounts shown in Step 2, such as mounted on the side or front of a helmet.

If you choose Auto, your camera will attempt to automatically adjust to the correct orientation. After rotating your camera, make sure the camera has changed to correct orientation by looking at the LCD Status Screen icons to make sure they are in the correct orientation. Once you start recording, the orientation is locked, so the orientation is based on the beginning of your video clip.

DFLT Mode

This defines which capture mode you want to be in when you turn your camera on. The default is Video Mode/Video, but if you find that you are using a different mode the majority of the time, you can set your preference here.

QuikCapture

QuikCapture allows you to **turn your camera on and begin recording video or time lapse photos instantly**. When you stop recording, your camera turns off.

After you enable QuikCapture and turn your camera off, you can turn it on into video mode by pressing and releasing the top Shutter button. To turn your camera on into time lapse photo mode, press and hold down the top Shutter button until your camera is powered on in time lapse mode and taking photos.

In QuikCapture, your camera will record in the last settings you selected for video or time lapse mode.

To turn QuikCapture off, power on your camera by pressing the front Power/Mode Button and turning it off in the Setup Menu.

The benefits of using QuikCapture are that it conserves battery life that would be used during standby time.

QuikCapture is extremely useful if you are having problems with your camera fogging up (Try to prevent this by reading the Anti-Fogging Tip in the Standard Waterproof Housing mounting tips in Step 2). By turning the camera off in between recording, QuikCapture allows the camera to cool down and the moisture inside your water housing should dissipate.

The downside of using QuikCapture is that it takes a few seconds for the camera to turn on so it is not recommended for fast action when you need to start and stop recording quickly.

LED Lights

You can **control the amount of LED lights that light up** on your camera. The options are all 4, 2, or to turn them all off. The LED lights flash while videoing or taking photos. Sometimes if you are filming close to your subject, the red glow from the LED lights can show up on your subject. Also, if you are recording video at night, the LED lights are bright so turn them off if they are affecting your scene.

 Beeps

This allows you to **turn the volume of the beeps to 100%, 70% or completely silent**. The beeps are helpful to let you know if your camera stops recording when your camera is mounted out of sight, on your helmet for example. If you are recording nature or music, the beeps tend to be loud and distracting so you may want to turn them down or off.

 NTSC or PAL

If you are in North America, film in NTSC. If you are outside of North America, most televisions outside of North America use PAL, so set your camera to PAL. Setting your camera to PAL will affect the frame rates as shown in the video settings section.

OFF Auto OFF

If you find that you keep forgetting to turn off your camera and the battery dies before you get a chance to use your camera, you can **set your camera to shut off automatically** after 1-5 minutes off inactivity. The default setting is to never turn off automatically.

Date /Time

Set the date on your camera. If you have any hope of staying organized with the huge number of files produced by a GoPro camera, you need to be able to search through your files by date. So, before you record any more footage, go into the Setup Menu and make sure the date is correct. If you connect your camera to the GoPro App, the date will be set automatically.

Delete

After you transfer footage to your computer, select All/Format to erase all of the files. You can also erase just the most recent file.

ADDITIONAL SETUP TIPS FOR A SUCCESSFUL SHOOT

• If you attach an **LCD BacPac** to your HERO4 Black, a **Playback Mode** option will also appear in the main menu before the Setup Menu.

• **Make sure to turn your camera off when not using it.** If you forget, you will end up with a dead battery the next time you go to film something.

• **Erase the old footage after you download it**. It's a lot easier to erase all files before you record anything new. Once you have one new file on the camera, it takes a long time to go through and erase the old files one by one, especially if you are already back out having fun.

CONGRATULATIONS, YOU'VE MADE IT THROUGH THE TECHNICAL NITTY GRITTY. YOU ARE NOW READY TO MOVE ON TO STEP 2 WHERE YOU WILL LEARN HOW TO MOUNT YOUR CAMERA!

STEP TWO
MOUNTING

Set Up Your Camera To Work The Angles

The quality that really makes GoPro cameras stand out is their ability to be mounted in unique locations to capture angles that used to be unwieldy or nearly impossible. Getting creative with mounts is what will make your footage truly unique.

There are hundreds of ways to mount your GoPro camera and the possibilities keep expanding as creative users come up with new mounts and new mounting techniques. If there is an angle you can imagine, with a GoPro camera, there is a way to capture it. And the best part is that these cameras are so small and lightweight that they are hardly even noticeable as you carry them along with you on crazy adventures.

So study up and learn how these mounts work so you can decide which ones will best capture your point of view.

This chapter begins with the basic elements- the housings and backdoors- and then gets deeper into the wide variety of mounts you can use to get the angles you want to capture.

Other companies besides GoPro make versions of many of these mounts, however this book only points out other available options when they offer something unique from the original GoPro mounts.

ACTIVITY LEGEND

As you learn about each mount, you will see the following icons which are shown to recommend which activities each mount is most useful for.

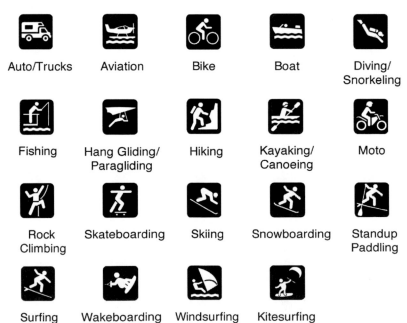

| Auto/Trucks | Aviation | Bike | Boat | Diving/ Snorkeling |

| Fishing | Hang Gliding/ Paragliding | Hiking | Kayaking/ Canoeing | Moto |

| Rock Climbing | Skateboarding | Skiing | Snowboarding | Standup Paddling |

| Surfing | Wakeboarding | Windsurfing | Kitesurfing |

HERO4 BACKWARDS COMPATIBILITY

The HERO4 Black Edition camera body is the same size as the HERO3+ and HERO3 cameras and can be used in any of the HERO3 housings and vice versa.

The backdoor from a HERO4 housing will fit onto a HERO3+ housing (but not on a HERO3 housing) correctly, and vice versa, so if you have an old Floaty Backdoor from a HERO3+, you can use it on your new HERO4 housing.

GENERAL MOUNTING TIPS:

• **Secure your angle!** Once you have figured out exactly how you want the camera pointing, **use a Philips screwdriver to tighten the thumbscrews** that hold the camera in place. If you don't tighten the screws properly, especially if you are in water, the camera will probably move around and you won't know if you are still capturing the right angle. Even small bumps and shakes can move your camera around very easily, so use a screwdriver to tighten the thumbscrews as tight as you can. Alternatively, GoPro makes the Tool, which is used to tighten thumbscrews and fits into your pocket better than a screwdriver.

• Use the **longer Thumbscrew to connect the camera to mounts** and the shorter Thumbscrews to connect the mounting pieces together.

• If you lose the nuts that hold the Thumbscrew, you can pick up **replacement nuts** at a hardware store. Look for M5 x 8mm Acorn nuts, but they don't necessarily need to be Acorn nuts to work properly.

• Some of the newer mounts have the nut permanently attached, but on mounts that have a loose nut, you can super glue the nut in place on the mounts. Make sure glue doesn't get on the thread. **Do not fill the Thumbscrew with glue** because you need to use a screwdriver to tighten the screw for certain mounting positions.

• You can **use an extension arm** with many of the mounts to capture unique perspectives. An extension arm can be used to lift your camera up from a low position or to move your camera out and away from a helmet or board. Using an extension on a helmet tends to feel awkward because of the weight, but it can produce some unique perspectives. The Smatree Aluminum Arm or the GoPole Arm are two premade extensions you can use.

CAMERA HOUSINGS

A camera housing holds your HERO4 camera, enabling you to attach it to the mounts using a thumbscrew. There are five HERO4 compatible housings and they can be used with all of the mounts. Each housing has its benefits, so read on to learn more.

STANDARD WATERPROOF HOUSING

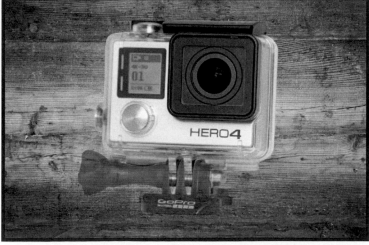

The Standard Waterproof Housing comes with the HERO4 Black Edition Regular and Surf Editions, but not the Music Edition. The standard waterproof housing is a plastic case that encloses your camera and protects it from the elements and rough handling. When used with the waterproof backdoor, the combo creates a **compact, watertight housing** that can handle 131'/40m of depth, not that most people will ever go that deep underwater. The Waterproof Housing has a flat lens port (the portion directly in front of the lens) that protects the lens and creates clear shots in all situations (even underwater). This durable case is the **go-to housing for most action sports** where your camera may get wet, dirty, dusty or dropped!

Mounting Tips:

• **Always make sure the top latch is completely closed all the way across!** It's is a common mistake for the latch to grab the lip of the housing on one side, but not be fully latched all the way across. If this latch is not completely closed, water will leak in and ruin your camera.

• The audio is muffled when used with the Waterproof Backdoor, although the thin walls of the housing let some audio reach the camera. If you are not using your camera in the water or rough elements, use the Skeleton Backdoor for improved audio.

• The glass piece directly over the lens on the waterproof housing is called a "lens port". When using your camera in the water, water drops on your lens port will quickly ruin your shot. **To prevent water drops in front of your lens when your housing gets wet, lick your lens port** (not your camera!) and let it dry before you get in the water. When you get in the water, dip the housing to give it a quick rinse. This is an old surf photographer trick and it works really well to prevent water from beading up into visible drops on the lens port. You may need to repeat it a few times during your session. Don't use Rain-X on the outside because this actually makes water bead up and get in the way of your shot.

• **Don't touch the lens port with your fingers.** You don't want grease or sunblock on the lens port. Make sure your lens port is always clean!

• **Underwater photos and video.** The flat lens port that comes with the HERO4 works great for clear, in-focus underwater shots. Several companies make underwater filters (a red one works great!) that fit the HERO4 housing and help to correct colors underwater. See the section on Filters in Step 6 for more about which filter is right for you.

• **Rinse off your camera with fresh water** after using it in the ocean. Gently dry your housing with a soft cloth and blow off the water around the backdoor before opening the housing.

• **Keep the seal on the backdoor clean of sand, dirt and mud.** This is what keeps the housing watertight. Any debris on the seal can prevent it from doing its job of protecting your camera.

• **Keep your camera clean!** This may sound obvious, but if there is one place and time where you should be obsessive about cleanliness, this is it. All it takes is one fingerprint or a piece of dust, lint or sand to ruin your shot. If there is anything inside your waterproof housing besides your camera, it will increase the chances of it fogging up on you. Because these cameras are so small, they sometimes will fog up on you regardless in certain weather conditions. The best prevention you can take is to keep everything clean. Take the extra time to clean your housing thoroughly or your entire filming session might be ruined by a fogged up housing.

• **ANTI-FOGGING TECHNIQUE**: Because of their compact size, getting fog on the inside of the water housings is a major issue for GoPro® cameras. If you follow these steps, it will minimize the amount of fogging.

1. Lightly spray the inside of the front of your housing with an Anti-fog spray. You can find the spray in sporting goods stores for dive masks and swim goggles. Alternatively, you can use Rain-X Interior Glass Anti-fog solution. Be careful not to spray too much and don't get spray on the back door or seals. Then wipe it off with a soft cloth and let it dry thoroughly.

2. Once your housing has dried out and you are inserting your camera, use **Anti-Fog inserts** to prevent your housing from fogging up. These will help absorb the extra moisture that naturally occurs. Make sure you put inserts into the housing as directed (two inserts fit in the HERO4 housing) without adding any extra pressure on the backdoor. Install the Inserts into the housing horizontally, pushing the inserts in far enough so they **do not interfere with the white rubber seal on the backdoor that keeps the housing watertight.** Any time you have to open your housing to charge the camera or download footage, throw the Anti-Fog inserts in the oven for 10 minutes to keep them nice and dehydrated.

3. If you are going in the water and there is a big difference between air and water temperature where you live, when you

first get in the water, **put your HERO4 camera (sealed in the waterproof housing of course) underwater** for a few minutes to acclimate it before you turn the camera on.

4. If your camera got dirty or wet during your session, rinse your water housing with fresh water and dry it off thoroughly. **Blow off the residual water around the backdoor** to prevent even the tiniest amount of water from getting inside your housing when you open it.

TIP: If you choose to use different housings, always look at your housing before putting it in water and ask yourself- *Is this set up waterproof?*

THE FRAME

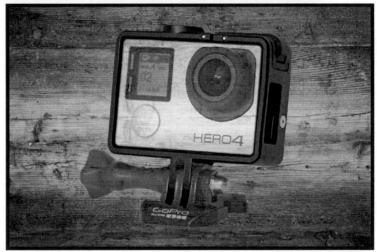

The HERO4 Music Edition comes with The Frame.

The Frame is a lightweight plastic case that wraps around the edges of your camera, allowing you to mount your naked HERO4 without the waterproof housing when you are not in extreme conditions. When your camera is in the Frame, there is no protection for the front of your camera or the lens, so GoPro includes a protective lens with the Frame. There is no noticeable difference between image quality while using the Frame or the Standard Waterproof Housing.

The Frame is an **excellent choice for recording audio** without any interference from the waterproof housing during low-impact activities.

Mounting Tips:

• If you want to enhance your audio recording, there is an opening in the side of the Frame, which allows you to plug in a microphone using the GoPro 3.5mm mic adapter.

• When you use the Frame, you lose the durability you will grow to love and depend on. The camera feels "naked" so be extra careful not to expose the camera to harsh elements while it is in the Frame. The FRAME is **NOT WATERPROOF**, so do not use it if you are going to be around water.

• To insert your camera into the Frame, align the Shutter Button on the Frame Mount with the Shutter Button on your camera, lift the tab on the top right side to flex the frame open and slide your camera into the mount.

• Mount the frame using a thumbscrew like you would typically mount your waterproof housing to other mounts.

• Remove the door to the USB port so you can connect your camera to your computer without removing it from the Frame.

• The GoPro Frame Mount can also be used with a BacPac (Battery or LCD). When using a BacPac, rotate the small metal clip out to hold the BacPac in place.

SKELETON HOUSING

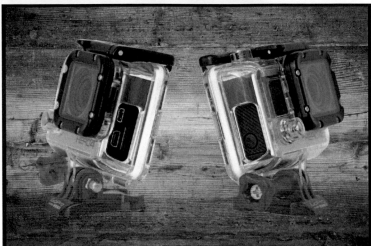

The Skeleton Housing is a NON-WATERPROOF version of the Standard Housing. The Skeleton Housing has open sides and comes with a Skeleton Backdoor to allow for **better audio and access to the USB port** for charging, external power supply (for long time lapses), and live-feed video. The housing provides protection for your camera and lens so that it is not completely exposed to the elements, like it is with The Frame, but it is NOT waterproof so only use this housing in DRY conditions.

Mounting Tips:

• This housing mounts with a long thumbscrew just like the Standard Waterproof Housing, except **it will not have problems with fogging** because the case is not completely enclosed.

• In low-speed situations, the Skeleton Housing **picks up less wind noise** than The Frame.

• This housing is **NOT waterproof**, so don't mistake it for the Standard Waterproof Housing and put it in water.

OTHER AVAILABLE HOUSINGS

BLACKOUT HOUSING

The Blackout Housing is a waterproof housing that serves the **same purpose as the Standard Waterproof Housing**, but it comes **in a matte black finish**. It also comes with a black sticker to cover the LCD Status Screen, creating an incognito camera housing when you don't want your camera to be noticed.

DIVE HOUSING

The Dive Housing serves the same purpose as the Standard Waterproof Housing, but the thicker case **can go deeper** underwater. Waterproof to 197'/60m, this housing is built for serious divers who want to go deeper.

BACKDOORS

The Backdoors are used with all of the housings except for The Frame and can be swapped out by popping the metal bar out of the clip on the bottom of the housing. The different Backdoors have their benefits, so knowing when each one is useful will help you make the right choice and get the shots you want.

STANDARD WATERPROOF BACKDOOR

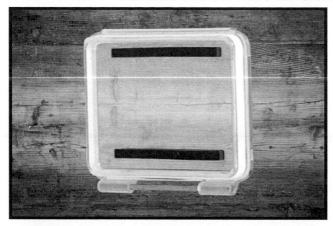

The Standard Waterproof Backdoor is a solid plastic backdoor that should be used in any situations where your camera is prone to get wet. This backdoor on the Standard Waterproof Housing creates **a completely waterproof and weatherproof camera** that can handle the most extreme elements. The drawback is that audio recordings are sometimes muffled because of the completely enclosed housing.

SKELETON BACKDOOR

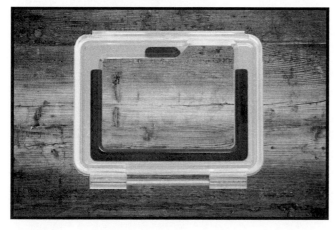

The Skeleton Backdoor has openings in the backdoor to allow for better audio recording (in winds under 100 mph). The Skeleton Backdoor is NOT waterproof so if there is a possibility that your camera may get wet, don't use this backdoor. But in the right "dry" situation, and if the audio is important to you, the Skeleton Backdoor is the one to use.

It's a good idea to color your non-waterproof backdoor using a marker or paint so you always know when it's on there to prevent you from accidentally submerging your non-waterproof housing.

FLOATY BACKDOOR

Make Sure it Floats! GoPro® cameras sink quickly! The Floaty Backdoor is a piece of foam that you stick to the back of the waterproof backdoor. If you are using your camera in the water, use a Floaty Backdoor so that your camera will float if it gets loose. It's a small investment to prevent your camera from sinking to the bottom of the ocean or lake. GoPro makes a Floaty Backdoor and you can also get a third-party version from GoFloatIt. The GoFloatIt version comes with a lanyard/leash on the floaty so you can easily secure your camera.

BUCKLES

Many of the mounts in the following two sections require that you use a "Buckle" to slide your HERO4 into the mount.

Your camera is attached to the buckle using a long thumbscrew. The buckle then slides into the mount, locking your camera in place.

There are two buckle options to choose from when mounting your camera on a mount base and each has its benefits.

TIPS FOR USING THE BUCKLES

• The buckles can be inserted into the mount bases **forwards or backwards**.

• You can **add more extensions to the buckle** if you need to change the orientation of your camera. Each piece of the 3-Way Pivot Arm that came with your camera rotates the camera 90 degrees, so if you are just looking for more height but want your camera to point the same direction, you will need to use two extension pieces. Make sure to **tighten each joint** so there is no weak point that will move under pressure.

• Use the **white locking plug with the Horizontal Surface Quick Release Buckle** (see the example below) to secure your mount in place during high-impact activities. The white locking plug also helps to reduce vibrations.

HORIZONTAL SURFACE QUICK RELEASE BUCKLE

The Horizontal Quick Release Buckle is **for low-profile mounting positions** where you don't need a lot of rotation to get the angle you are looking for. This buckle works best for horizontal surfaces, but doesn't need to be used only on horizontal surfaces. It provides a securely mounted position that **can handle a lot of impact** for extreme moments.

VERTICAL SURFACE J-HOOK BUCKLE

The J-Hook Buckle allows for a **great range of motion** for vertical mounting positions where you need extra front to back rotation to get your camera into the right angle.

It can also be used when your mount is in a horizontal position to provide more distance from the base mount. This buckle works great for **tricky angles on helmet cams** or when you need extra height from the surface where your camera is mounted.

ADHESIVE MOUNTS

When properly applied, Adhesive Mounts are the most secure base for mounting your camera to most surfaces. The Adhesive Mounts stick to smooth surfaces using a super strong adhesive tape. They are removable, but they are typically left on for more permanent use. It is especially important to follow the mounting instructions if you are using the mount in cold weather. The following tips will help you use the Adhesive Mounts to their full potential.

TIPS FOR USING ADHESIVE MOUNTS

• **Do not apply the mounts to a flexible surface**, like the nose of a snowboard. The mount will most likely come off when the surface flexes.

• To **remove a mount** from a tough surface, you can usually pry it off with a butter knife. If you are worried about damaging the surface, use a hairdryer to soften the adhesive and slowly peel it off.

• When setting up a new angle, the best option is to **always use a new mount**. If you have to reuse a mount, make sure to use a new piece of a super strong adhesive. **3M VHB 4991** is the bonding tape that comes on GoPro® mounts and this is a super strong adhesive tape. You can pick up a roll online and it's always good to have on hand. To reuse a mount, peel off the old adhesive and stick on the new mounting tape. If the mounting tape is in strips that are narrower than the mount, use multiple strips as close together as possible. Then trim off the excess using scissors.

• If your mount doesn't fit flush on the surface you are working with, on the top of your helmet for example, you can secure it using a sun-curing surfboard repair resin like Solarez. Make sure to just apply the resin around the base of the mount, not on the part of the mount where the camera slides in.

• When possible, use a camera tether for backup.

• Adhesive mounts can withstand temperatures up to 250°F (121°C).

• When mounting your camera, **make sure the buckle "clicks" into place** so it is locked into the mount.

• **ADHESIVE MOUNT MOUNTING INSTRUCTIONS:** Follow these steps to securely mount your camera using an adhesive mount:

1. First check to **make sure you are using the right adhesive mount** for the surface you are mounting to. If you are mounting to a flat surface, use the Flat Adhesive Mount or Surfboard Mount. When mounting to a curved surface, use the Curved Adhesive Mount. Before removing the backing from the adhesive, test the mounting position to make sure the edges of the mount sit flush on the surface.

2. Use isopropyl alcohol to **clean the surface** where you are going to place the mount. Make sure there is no wax or sand on the surface. Let the alcohol dry or wipe clean before moving to the next step.

3. Decide which direction you will want the camera to face when mounted and **make sure the groove for the camera to slide into faces that direction**. You can insert the camera forwards or backwards, but you can't rotate the camera once it is mounted.

4. The mount works best if **applied at room temperature**. Peel the paper backing off of the mount and stick the mount to the surface. NOTE: The adhesive does not feel extremely sticky to the touch and needs to be pressed hard onto the mounting surface.

5. For the strongest bond, **wait 24 hours before placing your camera into the mount** to let the adhesive form a strong bond. After 72 hours, the mount will be fully set to the surface.

CURVED ADHESIVE MOUNT

The Curved Adhesive Mount has a slightly curved base **for mounting to rounded objects**, most commonly a helmet or a curved surface of a vehicle. The Curved Adhesive Mount can be easily distinguished from the Flat Adhesive Mount by its square corners.

Mounting Tips:
• Follow the Adhesive Mount Mounting Instructions in the beginning of the Adhesive Mount Section to set up a secure mount.
• When using this mount on a helmet, **find the best position and curve to match the base of the mount**. Inspect all the edges of the mount to make sure you have a good fit. If the edges of the mount lift slightly because the curve of the mount doesn't match the curve of your helmet, you can secure it using a small amount of epoxy or sun-curing surfboard resin (like Solarez).
• Depending on what type of action you are filming, when the camera is mounted on top of your helmet, point the camera slightly down so that you don't just get footage of the sky.
• This is the mounting base to use with the Front Helmet Mount and Side Mount.
• See the Helmet Mounting Tips for ideas on where to mount this for Helmet Cam angles.

Mounting Example:
MOUNTED ON A HELMET WITH AN EXTENSION

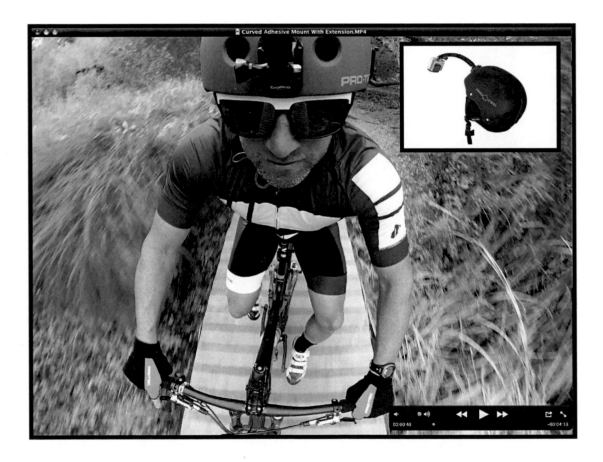

• SETTING USED FOR THE ACTION SHOT: 1440p @ 80fps WIDE. 1440p captures a larger top-to-bottom view of the action which can be cropped for a 1080p edit. 80fps creates the opportunity for slow motion clips during editing. The extension pictured is made by GoPole.
• The weight of the camera on the extension in this position is definitely noticeable, but it's worth it for the unique angle. Make sure the camera is lifted up high enough so that it does not block the subject's view.

Also, see the Helmet Camera Front Mount and the Side Mount which are used with Curved Adhesive Mounts

FLAT ADHESIVE MOUNT

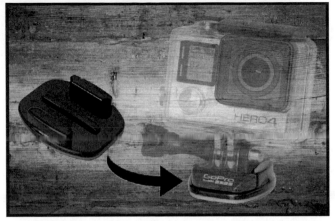

The Flat Adhesive Mount is a simple, low-profile mount that you can **stick to flat, non-flexible surfaces**. The Flat Mount has a flat base and rounded corners. When mounted properly to a flat surface, this mount provides a secure, semi-permanent base to hold your camera. The best application for the Flat Adhesive Mount is to a location where you can use the mount repeatedly- e.g. your own car, plane, boat, or sporting equipment.

Mounting Tips:

• Follow the Adhesive Mount Mounting Instructions in the beginning of the Adhesive Mount Section to set up a secure mount. The mount is very unlikely to fall off if mounted as instructed on a non-flexible surface.

• Once the mount is adhered, it can NOT be relocated using the original adhesive.

• For a secure mount in applications where a typical adhesive mount might come off, you can **modify the mount so that it can be drilled into a surface**. To do this: 1) Drill a hole in the middle of the mount, 2) Countersink a hole for the head of the screw (so it doesn't interfere with your camera sliding on) and 3) Screw or bolt your mount onto your board, surface, etc.

Mounting Example:

ON THE BOTTOM OF A SKATEBOARD

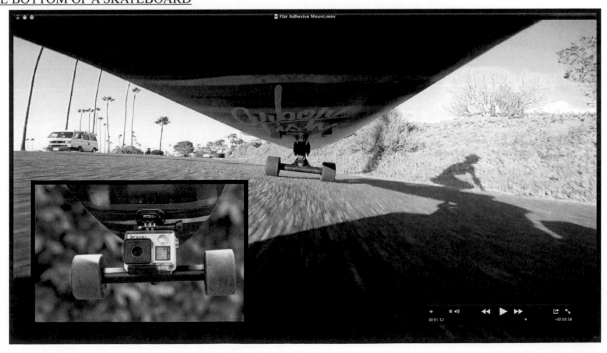

-SETTING USED FOR THE ACTION SHOT: 1080p @ 60fps SuperView. The SuperView aspect ratio setting allows the extra wide angle to capture more of the action. SuperView was chosen because the skateboard wouldn't show the distortion at the edges of the frame. 60 frames per second allows for slow motion, but the shot did not need the full 80 frames per second possible.

Other Available Versions:
• K-Edge's Go Big Adapter Mount comes with two counter sunk holes so you can screw your mount onto any surface you drill holes into.

SURFBOARD MOUNT

The Surfboard Mount is a flat adhesive mount with **more surface area** than the standard Flat Adhesive Mount. It comes with a separate tether mount that fits together snugly with the cutout on the Surfboard Mount. The extra surface area creates a stronger bond, and along with the included tether mount, this mount is a safe bet for holding onto your camera, even in big surf.

Mounting Tips:
• Follow the Adhesive Mount Mounting Instructions in the beginning of the Adhesive Mount Section for a secure mount.

• When putting your camera into the mount, insert the tether through the tether mount first. Then, follow the instructions for attaching a tether from the next section on Camera Tether Mounts. Your camera will fit through even with a Floaty Backdoor, although it is a snug fit. Finally, slide your camera into the Surfboard Mount.

• Because of the extra surface area, you need to **find a larger flat area** for this mount to adhere securely. Sometimes, it can be hard to find a large, flat area in the location you want it, like on the nose of a short surfboard.

• If you are mounting it to a board at deck level, **angle the camera back** so you get more of you and less of the board in the frame.

• You can use the J-Hook Buckle to get more front to back rotation, however the Horizontal Surface Quick Release Buckle is sturdier for extreme conditions.

• Do not use this mount on a **SoftTop surfboard or bodyboard**. If you are riding a SoftTop surfboard or a bodyboard, **use the GoPro Bodyboard Mount** instead.

Mounting Example:

UNDERNEATH THE NOSE OF A LONGBOARD

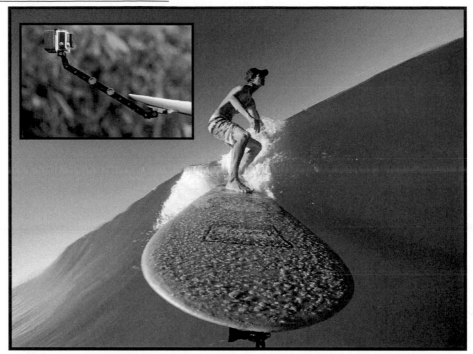

• SETTING USED FOR THE ACTION SHOT: Shot on the HERO4 Black Edition in Time Lapse Photo Mode at 12MP WIDE. Interval was set to 1 photo every .5 seconds. The full size WIDE photos allowed for the widest viewing area and had room to be cropped during editing. 1 photo every .5 seconds worked well for this shot to capture as many photos as possible per wave.

• This mounting setup is **not recommended for big waves**, but it works great for longboarding and smaller waves. The Surfboard Mount was mounted on the bottom of the surfboard as close to the nose as possible to minimize drag while riding waves. The camera was attached to an extension (by Smatree), which was connected to another extension piece from the Helmet Front Mount, (to allow the extension arm to rotate up above the nose of the board) which was then connected to a Horizontal Surface Quick Release Buckle. Each piece was tightened firmly with a screwdriver to prevent slipping. Alternatively, you could use a J-Hook Buckle attached to the extension arm.

Other Available Versions:

• BRLS Removable Suction Cup Surfboard Mount- Three suction cups attach the mount securely to any surfboard or clean, flat surfaces and can be easily removed. This is a non-adhesive alternative to the Surfboard Mount which is a great option when you are using someone else's surfboard.

CAMERA TETHER MOUNT

A Camera Tether Mount is a separate adhesive mount with a lanyard/leash that attaches to the camera to **provide backup in case the primary mount fails**. The adhesive mounts are unlikely to come off if applied correctly, but it's reassuring to know your camera will still be attached (albeit flapping around) if the primary mount fails.

If the primary mount does fail and the camera tether is holding your camera, you will want to stop whatever you are doing as soon as possible to prevent damage to your camera or the surface it is attached to.

You can use camera tethers anywhere that you can apply an adhesive mount.

Mounting Tips:

• Find a flat spot on whatever surface you are mounting the tether to. If you are mounting to a helmet, there should be a flat enough spot to adhere the small tether mount. Make sure it does not block the view of the shot when your camera is mounted. Follow these steps to attach the tether to your camera:

1. Before tightening your camera to the buckle, stick the end of the tether string between the two mounting pieces on the housing above where the Thumbscrew goes.

2. Attach your camera to the buckle and tighten the thumbscrew.

3. Pull the string through and loop it over the camera.

4. Pull the string tight just under the camera so you have formed a loop that holds tight onto your camera as long as it is mounted to the first thumbscrew.

Other Available Versions:

• You can also make a chain of clear zip ties to connect your camera to a stable object. Attach one end of the chain to a stable object and the other end to your camera. Make sure the diameter of the zip tie connected to your mount is small enough that the camera or mount can't slip through it.

HELMET & WEARABLE MOUNTS

Helmet and wearable mounts provide the ultimate point of view perspective. There are several ways to mount your HERO4 in a wearable position and each has its time and place. How and where you mount your camera while wearing it has a huge impact on whether you capture footage you want to watch or something that will just make you dizzy.

TIPS FOR HELMET & WEARABLE MOUNTS

Follow these general tips when setting up your camera with a helmet or a wearable mount.

• Use the **GoPro App for a live viewfinder** to see what your angle looks like while you are setting up your camera. This will help you to make minor adjustments to get the angle you want. The LCD BacPac is not very helpful when setting up Helmet and Wearable Mounts because you can't see the back of the camera to adjust the angle while it is mounted.

• For the most interesting footage, **set up your angle with something in the foreground** (your arms, board, vehicle, etc.) to give you a perspective of what is going on.

• **Use the Smart WiFi Remote while filming** so that you know if and when your camera is recording and to see what mode you are in. It's really hard to tell whether you are recording by listening to the beeps and it is inconvenient to pull your camera off to look at the LCD Status Screen.

• While filming with a camera mounted to your body, the steadier you can stay, the better your footage will be. If your footage is really shaky, **playing your footage back in slow motion helps to steady the shots**.

• **Make sure your helmet fits correctly**. If your helmet is loose, the extra weight of the camera will make your helmet move around on your head.

• **Best Settings for Wearable Mounts.** Because wearable mounts usually require Wide Angle shots and your camera is so close to you, a Standard 4:3 Aspect Ratio or SuperView resolution will capture more of the action in the frame. If you choose a Standard 4:3 Aspect Ratio and you want to show your footage in a Widescreen 16:9 Aspect Ratio, you can choose which part of the frame you would like to crop out or stretch it to fit the Widescreen 16:9 Aspect Ratio.

Also, because you are usually moving a lot, record at a high frame rate >48fps so you can slow down your footage to reduce shakiness.

- **Helmet Mounting Positions.** The three best locations for mounting your camera to a helmet are:
 1. Directly on top of your helmet using a Curved Adhesive Mount
 2. For helmets without a lip on the front, you can adhere a mount on the front of your helmet and use the Helmet Front Mount for a couple of unique angles
 3. On the side of your helmet using the Side Mount

HELMET FRONT MOUNT

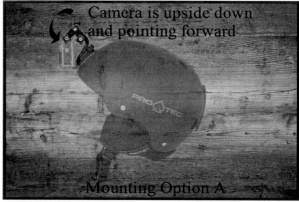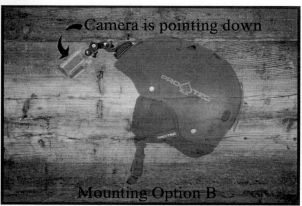

The Helmet Front Mount holds your camera onto the front of your helmet and can either point straight forward or point downward for self-portrait shots. The Helmet Front Mount is a great choice for **extreme sports where you want first person point of view footage**. This mount allows for a lower profile angle (as opposed to having the camera on top of your helmet), which means you don't have to compensate for the extra height of the camera above your head. This is especially helpful when going through trees or while you are surfing.

The benefit of using this mount as opposed to a J-Hook Buckle on a curved adhesive mount is that the extra pieces create more distance between you and your helmet providing better angles.

Mounting Tips:

- Use with the Curved Adhesive Mount to mount to your helmet.
- A helmet that has a visor or lip on the front will prevent you from being able to mount this on the very front of your helmet, where it works best
- For Mounting Option A: When pointing the camera forward on the front of your helmet, mount your camera upside down and flip the camera orientation in the settings (or you can flip the footage during editing). Notice which way the J-Buckle is facing in the image above to get your camera into this position.
- For Mounting Option B: When extending your camera out from the front of your helmet for a self-portrait perspective, get your camera in place and set up the angle using the GoPro App so you can adjust it while wearing the helmet. The J-Buckle goes in the opposite direction than in Option A. Once you are happy with the angle, you can take the helmet off and tighten the thumbscrews with a Philips screwdriver so that your camera doesn't flop down in front of your face if you have a heavy impact.
- Make sure your helmet fits securely so that the extra weight of the camera doesn't pull your helmet forward. The weight on the front of your helmet is noticeable, especially with Mounting Option B.

Mounting Example:
ON HELMET FACING FORWARD (OPTION A)

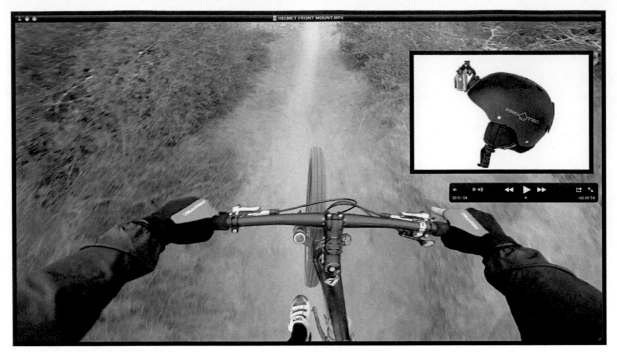

• SETTING USED FOR THE ACTION SHOT: 1080p @ 80fps SuperView. SuperView worked well for this shot to capture the widest angle of the scene since this is a body mounted point of view shot. 80 frames per second is the highest frame rate possible in this resolution for maximum slow motion of the quick action.

VENTED HELMET STRAP MOUNT

The Vented Helmet Strap Mount features two straps that are designed to be fed through the vents on your vented helmet and tightened for a secure temporary mounting position. However, because this mount has straps that lock it into place, you can also use this mount for a variety of other positions, including around your arm, ankle or backpack straps.

Mounting Tips:
• It is hard to secure the Vented Helmet Strap Mount as tight as an adhesive mount, so some people have had problems with it rattling on top of their helmet. If it's a really bumpy ride, an adhesive mount is a more secure option.
• Depending on the locations of your helmet vents, the Vented Helmet Strap can be mounted in a variety of locations. However, the most common and stable helmet mounting position for this mount is **centered on top of your helmet**.
• To mount on a helmet, put each of the straps in through one vent and bring it back up through the next vent over, then lock it into place using the clips. Try to get it as tight as possible without breaking the plastic clips.

• When wearing a backpack, you can tighten the straps **around the backpack straps** (with a J-Hook Buckle) by crossing them over each other and inserting them into the slots for a forward-facing view.

• Wear it **around your ankle** by crossing the straps over each other and then inserting them into the opposite buckles while snowboarding, skateboarding, surfing, paragliding, etc. for a unique ankle-level perspective. Because the mount tends to move around a lot in this position creating shaky footage, this angle works best for activities where your feet are in a set position so that you get a smooth shot. Use a J-Hook Buckle to get your camera angled in the right position. This mounting position can be a bit uncomfortable but is worth it for the unique angle.

Mounting Example:

<u>ON ARM</u>

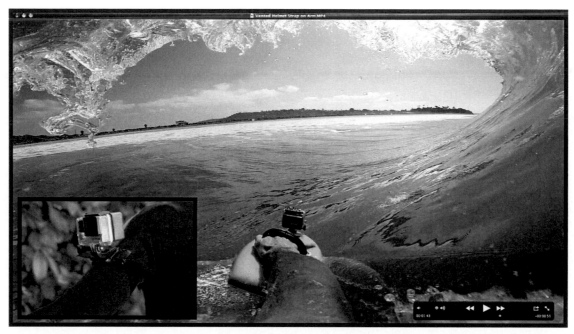

• SETTING USED FOR THE ACTION SHOT: 1080p @ 80fps SuperView. SuperView worked well for this shot because the camera was mounted so close to the bodysurfing handplane that it needed the widest view possible. SuperView was chosen instead of a Standard 4:3 Aspect Ratio because the edges of the frame could handle the distortion without being too noticeable. The fastest frame rate possible for 1080 SuperView (80fps) was selected to lengthen the short burst of action during a wave.

SIDE MOUNT

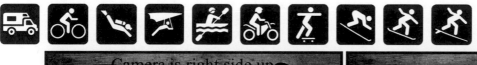

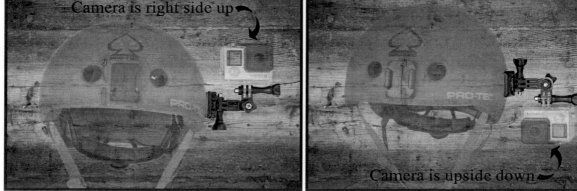

The Side Mount is designed for mounting your camera to the side of a helmet for an **eye-level point of view**. With the Side

Mount, you can get a portion of your helmet in the foreground for perspective. The Side Mount can also be used to mount your camera to the side of vehicles or any vertical surface.

The Side Mount is perfect for any first person point of view shots where your head is steady, like biking, motocross, surfing, snowboarding or on the side of a vehicle.

Mounting Tips:

• The Side Mount comes with a curved Adhesive Mount, but can also be used with a Flat Adhesive Mount, depending on the surface you are mounting it to.

• Attach the Curved Adhesive Mount with the Side Mount to the side of your helmet for a great angle. If you know that more action will be on a particular side of your body, mount your camera to that side.

• It is best to **have a helmet or goggles in the foreground**, rather than your face, because sometimes the distortion can make your face look distorted.

• You can mount your camera right side up or upside down, depending on your helmet and the angle you want to capture. If you record upside down, you can flip the orientation that the camera records in by using the Upside Down Mode in the camera settings (or you can flip it easily during editing).

• Because of the extra pressure on the mount in this position, the mount may need some backup adhesive. If the adhesive mount doesn't fit the exact curve of your helmet, apply some sun-curing resin or epoxy underneath the edges that are lifting up. Make sure not to get any on the face of the mount because this will interfere with sliding your camera into the mount base.

• Check the angle of your camera to **make sure the horizon is level**. It's a lot easier to make minor adjustments before filming than to correct them during editing.

• The weight of the side mount feels a bit off-balance because it is only on one side of your helmet. The Side Mount is not recommended for activities where the extra weight on the side of your helmet will throw off your balance.

Mounting Examples:

MOUNTED ON SIDE OF HELMET WITH CAMERA UPSIDE DOWN

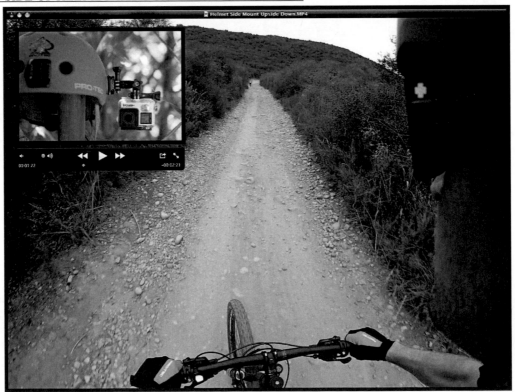

• SETTING USED FOR THE ACTION SHOT: 1440p @ 80fps WIDE. A Standard 4:3 resolution was chosen for this shot instead of a SuperView resolution to minimize the amount of distortion on the subject's face at the edge of the frame. This allows room for cropping to 1080p widescreen during editing. In this shot, the top of the frame will get cropped out. The maximum frame rate possible for this resolution works well to slow down the footage to smooth out the shakiness.

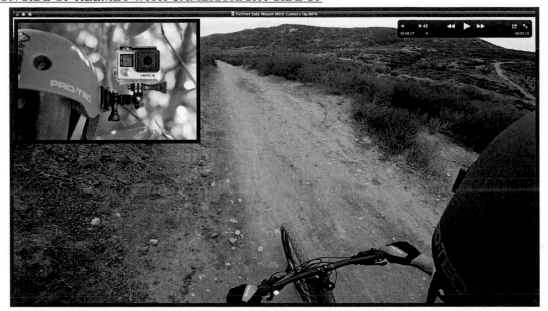

• SETTING USED FOR THE ACTION SHOT: 1080p @ 80fps SuperView. 1080 SuperView was chosen because the helmet on the edge of the frame could handle the wide-angle distortion without looking too odd. Because of the short distance between the helmet and the bike frame, the helmet-mounted shot required the widest view possible. This was a bumpy trail so the high frame rate works well to slow down the footage to smooth out the shakiness.

• For this type of shot, angle the camera down slightly and in towards the helmet so that it captures both the handlebars and the helmet in the shot.

CHEST HARNESS (aka CHESTY)

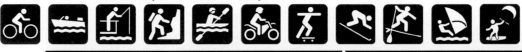

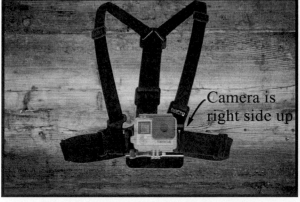

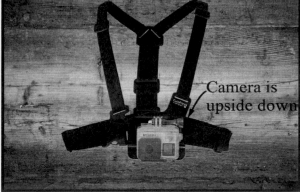

The Chesty (which also comes in a Junior Chesty size for kids 3 years and older) straps over your shoulders and around your body to put your camera right at the middle of your chest. This mount gets your **arms in the shot for a great point of view perspective** for a variety of activities like biking, motocross, and standup paddling. Since your torso doesn't generally move around as much as your head, the Chest Harness often produces more stable shots than a helmet/head mounted position.

Mounting Tips:
• Strap it on your chest and mount your camera right side up or upside down so it rests against the mount for stability.
• Mount your camera **upside down for biking or other activities where you are leaning forward** so that you can rotate the camera up, pointing it away from the ground.
• Mount your camera **right side up for shots where you are upright** so that you can slightly angle your camera down to get

some of your body in the frame.

• You can easily adjust the angle of your camera while it is still mounted on your body to see where your camera is pointing.

• The Chest Harness is not typically used with the LCD BacPac or Battery BacPac because it prevents your camera from angling back.

• The Chest Harness typically can't be used during activities where you have to lie on your stomach, like while paddling a surfboard.

Mounting Examples:

<u>MOUNTED ON CHEST WITH CAMERA UPSIDE DOWN</u>

• SETTING USED FOR THE ACTION SHOT: Taken in Time Lapse Photo Mode at 12MP Wide at an interval of 1 photo per second to capture photos of this cliff trail.

• The camera was mounted upside down so it could be tilted up slightly for any uphill sections.

<u>MOUNTED ON CHEST WITH CAMERA RIGHT SIDE UP</u>

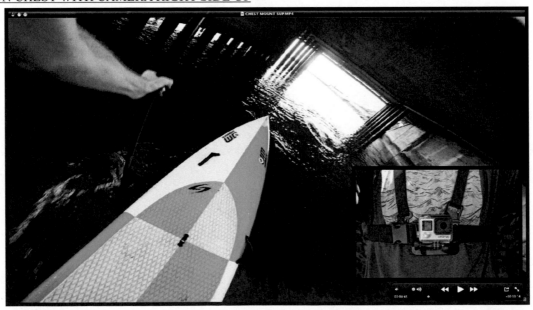

• SETTING USED FOR THE ACTION SHOT: 4k @ 24 fps. This setting was chosen because the action did not require slow motion and the desired output was 4k. SuperView was selected to capture the widest angle of this body-mounted perspective.

WRIST HOUSING

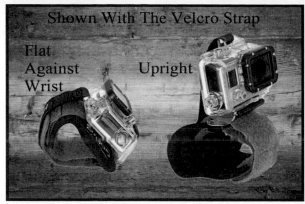 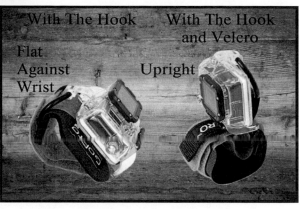

The Wrist Housing allows you to securely carry your camera on a wristband, either flat against your wrist by hooking it onto the clip or Velcro strap, or in an upright position for filming. The Wrist Housing is useful for sports where you need to use both of your hands. The Wrist Housing can also be strapped around a variety of other objects besides just your wrist.

Mounting Tips:
• To maintain the camera in an upright position when the Wrist Housing is on your wrist, wrap the Velcro around the Rubber hook like in the photo above (and first example below) and then slide it under the housing to hold your camera in an upright position.
• Keep it flat on your wrist for occasional photos.
• Sometimes getting the angle you want is awkward because the camera can not rotate 90°.
• The Wrist Housing can also be worn on your back wrist for surfing, snowboarding and other activities where you are in a side-ways stance. Position your camera on the inside of your wrist and aim as you ride.
• Strap it securely around objects, but remember the camera can't rotate on the mount so the object you are strapping the mount to has to be perpendicular to the angle you want to capture.

Mounting Examples:
<u>MOUNTED ON WRIST UPRIGHT</u>

• SETTING USED FOR THE ACTION SHOT: Taken in Single Photo Mode at 12MP Wide. The Wrist Housing provided an easy way to carry the camera during the hike and easily capture single shot photos along the trail.

ON YOUR WRIST FOR ACTION SPORTS

• SETTING USED FOR THE ACTION SHOT: 2.7k 4:3 @ 30fps. The 4:3 Aspect Ratio works well with the Wrist Housing because it is mounted on your body. Choosing a SuperView resolution will typically distort your body, depending on what type of angle you are capturing. The 2.7k resolution can be zoomed in during editing and still maintain full 1080p resolution. For high action, choose a higher frame rate.

HEADSTRAP MOUNT

The Head Strap Mount is an **easy way to get a quick helmet cam/head cam view** without having to adhere any mounts. You can slip it right on your head or slide it over a helmet. The Head Strap also comes with a Quick Clip that you can use for mounting your camera onto a backwards hat or any object that is 3mm-10mm thick. With a little customization, the head strap can also be worn on your leg or arm over thick clothing.

Although wearing your camera on your head can look goofy at times, the Head Strap and Quick Clip works well for a point of view perspective of mellow activities.

Mounting Tips:

• When wearing it on your head, **adjust the strap so that it fits your head or helmet snugly**. Wear it over a hat or beanie for a less-obvious approach.

• **Tilt the camera down slightly** so you aren't just getting a view of the sky, unless that's what you are aiming for.

• The top strap provides stability when you are using this over a helmet, but if you are wearing it directly on your head, **you can remove the top strap** to make it more comfortable. Simply slide the top strap out of the slots in the middle of the plastic piece where each side of the top strap attaches.

• If you are wearing the Head Strap over a helmet, **make sure the Head Strap fits snugly on your helmet** and that the rubber

traction is on the inside of the straps against the helmet so it prevents the Head Strap from slipping off. If it comes off, it's gone.

• You can also alter the mount and use the top head strap to make a strap that fits on your leg with pants or boots on. Remove the headband strap and use the top strap with the clip from the headband as a leg band.

• The Head Strap does not work well with the LCD BacPac or Floaty Backdoor because it prevents your camera from angling back.

• The Head Strap **can fall off** because it is not permanently attached to your head. If you wear the Head Strap in the water, do so cautiously in calm conditions because it can come off easily and will sink. Do not use the Head Strap for surfing, rough water kayaking or swimming in the waves.

• The plastic mounting piece can also be removed completely to be used as a **mouth mount for** surfing or attached to a kite strut with zip ties for kitesurfing. To make a mouth mount for surfing, use electrical tape to add a piece of foam to the top of the plastic piece. Then, mount your camera upside down with the Floaty Backdoor resting against your chin.

OTHER WEARABLE MOUNTS

NVG MOUNT

The NVG (Night Vision Goggle) Mount is exclusively for helmets equipped with the NVG plate, which is used on military and police helmets for night vision. NVG-equipped helmets are also used for airsoft, paintball and sometimes by pilots. During the day when night vision goggles are not needed, you can mount your camera to the NVG plate using this mount.

FETCH (Dog Harness)

If your dog wants to get in on the GoPro action, your dog will love the Fetch Mount, which is made specifically for dogs. The Fetch Mount enables you to capture great footage from your dog's perspective.

The harness mounts on your dog's torso with two mounting positions, one on top and one underneath your dog's chest. The soft, padded mount is comfortable for your dog and washable. Fetch is fully adjustable to fit dogs between 15-120 pounds.

<u>VERSATILE MOUNTS</u>

The mounts in this section can be used in a variety of ways to capture unique angles. These mounts are grouped together because they can be mounted temporarily to a variety of objects. Each of these mounts is quite unique and specific usage tips are given at each mount.

HANDLE OR POLECAM/MONOPOD

Attach your HERO4 to a handle (typically about 6"-8") or a pole (18"+) for an easy way to hold your camera and **capture multiple angles with one mount**. A handle or pole enables you to capture some of the best angles possible for any sport where you have a free hand. The pole allows you to get more distance between you and your camera so you can get more of the scene in handheld self-portraits. You can **film yourself, follow behind your friends, or hold the pole vertically** to get more height on your shots.

There are tons of options available for a well-designed handle or pole, or you can easily make your own (see the Handlebar/Seat-post Mounting tips for simple instructions).

If you are looking to purchase a premade handle, check out the Handler (by GoPro) which is pictured above, or the Bobber (by GoPole). Both options are waterproof and will float your camera.

For a well-designed pole, the 3-Way (by GoPro) is very versatile and can capture multiple angles when used with the extension arm. GoScope makes a telescoping pole and GoPole makes the Evo, which is clear, floats and is extendable from 14"-24". The PowerPole (by PolarPro) is not waterproof, but it features a built-in battery that allows you to film for 10 hours on a single charge.

Mounting Tips:
• Hold the pole steady while filming for smooth shots
• See below for the three primary ways to hold your camera when using a handle or polecam.

Mounting Examples:

THE FOLLOW-ALONG ANGLE

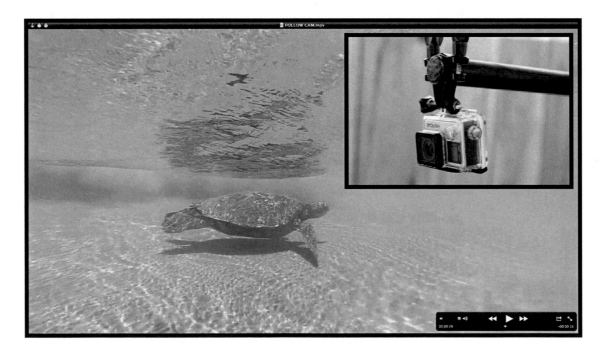

• SETTING USED FOR THE ACTION SHOT: 1080p @ 60fps WIDE. The extra distance provided by the pole works great for snorkeling and diving because it allows you to get close to the sea life.
• When you have your camera set up like this, flip the camera's filming orientation in the Setup Menu before filming so you can preview your footage right side up.
• Because the camera is upside down and facing out, this angle provides optimal stability for following behind your friends.

UPRIGHT POLECAM

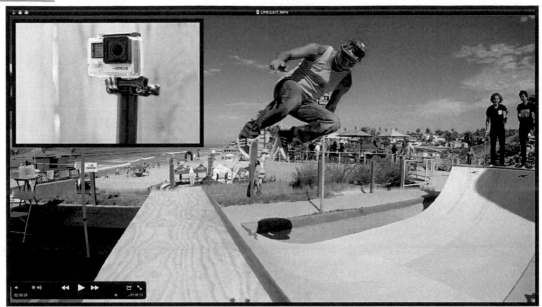

• SETTING USED FOR THE ACTION SHOT: 1080p @ 120fps WIDE. The high frame rate allows for super slow motion of the technical parts of the action. There was enough distance between the camera and the subject to record in Widescreen and capture the full scene.

• This mounting position gives you extra height to take photos or videos, usually of other people. Mounting the Smart WiFi Remote to the base of the pole is extremely useful for this mounting position, especially when shooting Burst action photos.

• By mounting the camera on the very end of the pole, you can still rotate the camera back even when using the LCD BacPac or Floaty Backdoor.

SELFIE SHOT

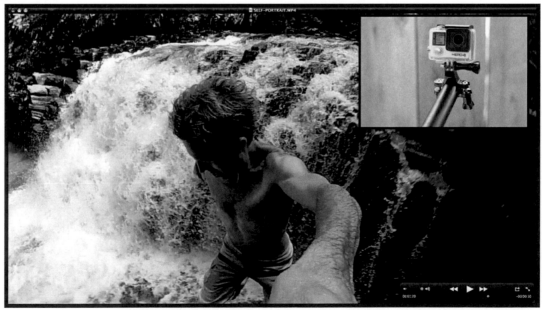

• SETTING USED FOR THE ACTION SHOT: 1080p @ 120fps WIDE. The fast frame rate allowed for great slow motion clips of this jump off of a waterfall. The camera was mounted on a custom 8" long handle made using the Handlebar Seatpost Mount. 1080p captured a wide angle without too much distortion.

• When you have a free hand to hold the pole, this mounting position allows you to film yourself and get extra distance between you and the camera for a better shot.

• If you choose to make your own pole or handle using the Handlebar Seatpost Mount, notice which direction the curved top of the mount is facing to allow you to rotate the camera back for less of the pole in the shot and more of you.

ROLL BAR MOUNT (pictured) & HANDLEBAR / SEATPOST MOUNT

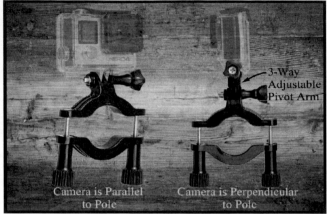

The Roll Bar Mount and the Handlebar/Seatpost Mount are very similar. Both mounts consist of two pieces that **clamp together around a pole** using thumbscrews. A J-Hook on one side of the pieces allows you to mount your camera in a wide range of angles.

The Roll Bar Mount fits onto larger pipes and poles with a diameter from 1.40" to 2.50" (3.50cm-6.35cm). The Handlebar/Seatpost Mount fits poles and tubes that are .75" to 1.40" (1.90cm - 3.50cm) in diameter.

These two mounts are very versatile, although the Handlebar Seatpost Mount fits on a wider variety of objects.

Some of the things you can do **with the Handlebar/Seatpost Mount** are:
- Mount it on a piece of PVC pipe for an **easy homemade polecam.**
- Mount it **to a paddle** while riding waves standup paddling.
- Put it **on ski poles** or on the ski rack in a sled.
- Attach your camera on your **bike handlebars, seatpost or bike frame**.

Use the **Roll Bar Mount for**:
- Mount your camera to **the strut of an airplane.**
- Attach it **to a bike frame**.

Mounting Tips:
- When mounting the Handlebar Seatpost Mount to your bike, if your bike seatpost is long enough, mount the Handlebar Seatpost Mount low on the seatpost with the camera mounted upright so that your legs don't rub on it while riding.
- **Make your own polecam/handle** by attaching the Handlebar/Seatpost Mount to the end of a 3/4" diameter piece of PVC pipe. Spray paint the PVC pipe with a matte black paint so it looks more stealth in your shots. If you are using the pole in the water, seal both ends with waterproof epoxy (Waterweld Epoxy works well) so it floats. See the previous mounting section (Handle and Polecam) for more tips on how to use a polecam.
- Make sure you are mounting the Roll Bar Mount or the Handlebar/Seatpost Mount to the properly sized pole or tube.
- After tightening the thumbscrews by hand, use a Philips head screwdriver or the GoPro Tool to give the screws an extra turn. **Tighten the screws equally** on each side until the mount doesn't rotate. **Don't over tighten** because too much pressure could break the mount.
- If you are mounting the Handlebar/Seatpost Mount to painted metal or other slippery surfaces, put the included protective liner around the pole to **prevent the mount from slipping**. The rubber also reduces vibration during filming.
- The Roll Bar Mount comes with an attached rubber liner that helps prevent the mount from slipping.
- Also tighten the thumbscrew that is connected to your camera and any screws on the pivot arm (if you are using it) to prevent your camera from moving once mounted.
- Be very careful not to lose the loose thumbscrew. This thumbscrew needs to be loose to be able to mount to a pole, but it can

get lost easily if you are not careful. When storing these mounts, tighten the thumbscrew so that the loose screw doesn't fall off.

• Make sure the **J-Hook is positioned in the right direction** like in the photo below so you **get the rotation you need** for your desired angle.

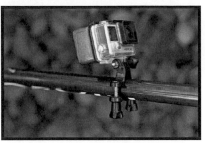

• Depending on the angle of your shot, you may need to use the included Three-Way Adjustable Pivot Arm to rotate your camera.

• The longer thumbscrews on the Roll Bar Mount (compared to the Handlebar/Seatpost Mount) can get in the way of certain mounting locations. If you can use the Handlebar/Seatpost Mount instead of the Roll Bar Mount in tight mounting locations, the Handlebar/Seatpost Mount will give you more flexibility.

Mounting Examples:

ON A BIKE FRAME

• SETTING USED FOR THE ACTION SHOT: Shot in Night Lapse Photo Mode at 12 MP WIDE with a 2 second Shutter setting at a Continuous Interval. This was one of the photos for a night riding time lapse clip.

• Try to use as few mounting pieces as possible to reduce shakiness. Adding a piece of rubber onto the bike frame before mounting the Roll Bar Mount also helps absorb some of the movement.

• Make sure to tighten the thumbscrews with a screwdriver so they don't loosen during the ride.

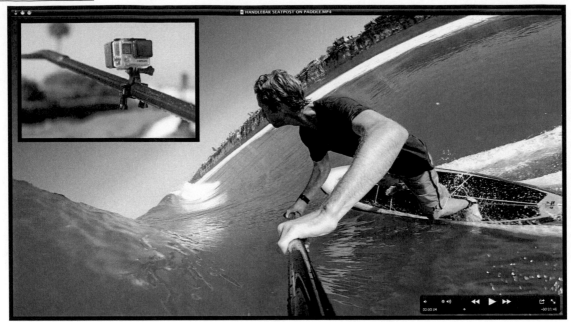

• SETTING USED FOR THE ACTION SHOT: 4k @ 24fps SuperView. Although this angle could benefit from a higher frame rate for slow motion, the desired output was for 4k. SuperView was selected to get the widest angle since the camera was mounted close to the subject.

• This mounting position is best for waveriding on a SUP. Mount the Handlebar/Seatpost Mount right above where your paddle would touch the board when you are paddling.

Other Available Versions:

• RAM Mount GoPro Roll Bar Strap Mount which is adjustable to any degree

• K-Big's Go Big & Go Big Pro Handlebar Mounts offer versions made out of aluminum for a solid hold.

SUCTION CUP MOUNT

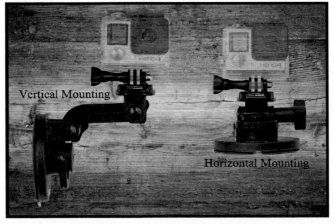

A suction cup mount uses an industrial strength suction cup at the base of the mount to **temporarily mount your GoPro camera** to a variety of surfaces including cars, trucks, boats and some sporting equipment. It comes with adjustable arms so you can customize the camera orientation for the shot you want.

The Suction Cup Mount is **the perfect travel mount** because you can temporarily mount your GoPro camera without using an adhesive mount. This mount also gives you the freedom to **quickly move your camera** to capture several angles.

Mounting Tips:

• Make sure you **attach the Suction Cup Mount to a flat, clean and smooth surface**, such as glass or painted metal. Check to see that the suction cup is clear of debris. The suction cup will not stick well to a porous, curved or flexible surface.

• The Suction Cup Mount is **NOT recommended for high-Impact sports** like snowboarding, motocross, and surfing (depending on conditions).

• Do NOT apply the Suction Cup Mount in an environment where the temperature is drastically different than where you will be using the Suction Cup Mount. If you are in the snow for example, don't attach the Suction Cup Mount in your heated car and then jump outside into the cold. This may affect the suction.

• Wet the edge of the ring with a little bit of saliva or water before pushing the suction cup onto the surface to get better suction.

• After pushing down the button and flipping over the lever to secure the mount, **pull firmly on the mount to test its suction**. When mounted correctly, the mount should not move at all.

• If you are using this mount in a situation where you will lose your camera if the mount comes off, use a leash tether or lanyard attached to a separate Tether Mount as backup in case the suction cup does fail. You can also use a chain of zip ties attached to a part of your vehicle if you don't want to apply an adhesive tether. Attach the other end of the zip tie chain to the arm of the Suction Cup Mount. You don't want to lose your camera!

• Always rinse your Suction Cup Mount with fresh water after use in salt water to prevent corrosion.

Mounting Examples:

<u>MOUNTED TO A WINDOW</u>

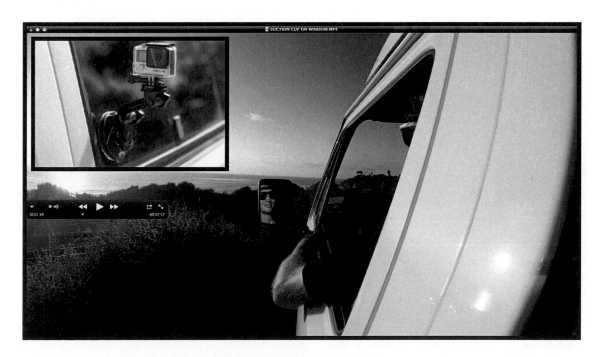

• SETTING USED FOR THE ACTION SHOT: 4k @ 30fps WIDE. The shot was set up using the GoPro App and since the final edit was going to be in Widescreen 16:9, it could be set up properly beforehand.

• Use a camera tether when the Suction Cup is mounted on the outside of a vehicle. Or, if you don't want to adhere a Tether Mount, use a chain of zip ties and attach it to your vehicle.

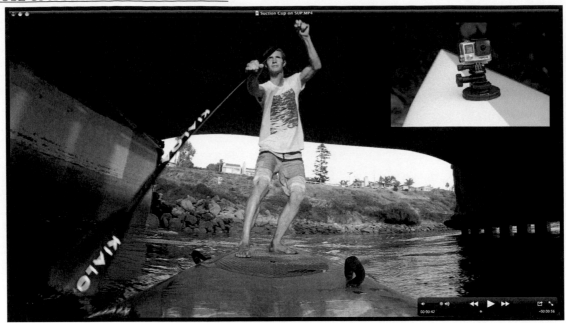

• SETTING USED FOR THE ACTION SHOT: 4k @ 30fps WIDE. Because there was enough distance from the camera to the subject, a Widescreen 16:9 Aspect Ratio worked well for this shot. This action does not require slow motion so the the full 4k resolution was the best choice to capture all of the detail in this shot.

• Use the Suction Cup Mount in the water cautiously. If you are using a Suction Cup Mount in water, be sure to use a Floaty Backdoor to provide more flotation. And use a tether mount when possible just in case the suction cup fails.

FOR WINDSHIELD MOUNTING

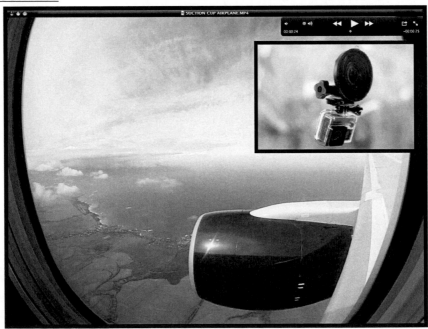

• SETTING USED FOR THE ACTION SHOT: 2.7k 4:3 @ 30fps WIDE. 2.7k 4:3 was chosen to capture the maximum top-to-bottom perspective without the distortion of SuperView and slow motion was not needed for this scenic shot.

• When mounting your camera to a car windshield, mount your camera upside down and flip the orientation in the Setup Menu.

Other Available Versions:

• RAM Suction Cup Mount for GoPro

• VectorMount (features three suction cups and a naturally rotating head, made specifically for vehicles)

TRIPOD MOUNT

The Tripod Mount is a small piece of plastic that has a standard 1/4"-20 threads per inch screw so you can mount your camera to any tripod. This mount, as small and simple as it is, really opens up a lot of possibilities for different shots to mix in with your other action shots, such as scenic shots and self-portraits where you set up the shot and then pass by the camera.

Mounting Tips:
• A tripod is the best partner to utilize this mount.
• A small, flexible tripod like the inexpensive Dynex Flexible Tripod or the GorillaPod opens up a myriad of options for unique angles.
• The Tripod Mount also comes with a Quick Release Tripod Mount allowing you to easily slide your camera on and off of a tripod.
• Because this mount enables you to attach your camera to any 1/4"-20 screw, there are tons of custom mounting options, including on top of a DSLR camera to record video in addition to the photos you take with your DSLR. (See ON TOP OF A DSLR Example for mounting instructions.)

Mounting Examples:
ON A TRIPOD

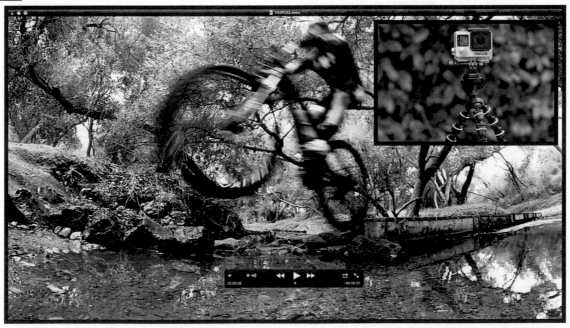

• SETTING USED FOR THE ACTION SHOT: 1080p @ 120fps WIDE. Since there was distance to set the camera back from

the subject, 1080p was used for this shot. 120 frames per second allows for super slow motion when the bike splashes in the river, while the lead up can be played at regular speed for a dramatic effect.

<u>ON TOP OF A DSLR</u>

• If you are shooting with a standard lens on your DSLR, the lens will most likely be out of the GoPro video frame. However, check the shot using the GoPro App or LCD BacPac. If the lens is in your shot, rotate your HERO4 up to get the lens out of the frame or switch to Narrow video mode to get a tighter shot.
• Use a Hot Shoe to 1/4"-20 Tripod Screw Adapter (available online, but not from GoPro) along with the Tripod Mount to mount your HERO4 to the top of your DSLR so you can record video or time lapse photos with your GoPro® camera while taking photos with your DSLR.

JAWS: FLEX CLAMP

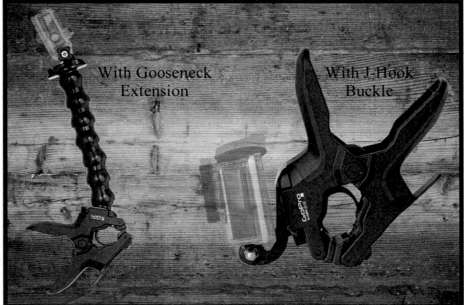

The Jaws: Flex Clamp has a **very strong grip** and comes with a flexible arm that can be used for a variety of mounting options. The clamp can be quickly and easily mounted and removed for easy shots on the go.

Mounting Tips:
• Use a **J-Hook Buckle in conjunction with the clamp** so that you can rotate your camera all the way back as shown in the

mounting photo on the previous page.

• The **Gooseneck Extension enables you to rotate your camera** if you use the clamp on a vertical pole or tree.

• The **rubber tab** on the clamp can be **pulled to tighten the grip** when you are clamped onto a round object.

• Jaws **can also be used as a handle**. Hold the clamp in your hands with the camera upside down facing out for maximum stability.

Mounting Examples:

ON A FENCE

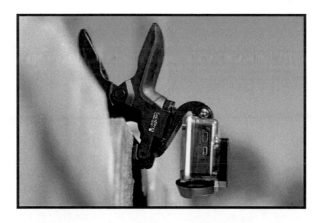

ON A SKATEBOARD

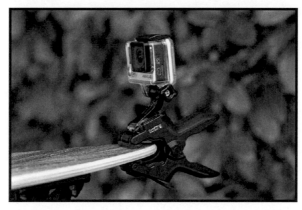

Other Available Versions: (Both of the following options require the Tripod Mount to mount your GoPro to their products)

• ActionPod offers a clamp with a bendy arm.

• Pedco makes a wide variety of camera clamps.

BASE PLATE MOUNT (INCLUDED IN CAMERA PACKAGING)

When you bought your HERO4, this is the plate that your camera was mounted to for display. A lot of people throw this away thinking it is just part of the packaging, which was its original purpose. But hold onto it because it's like a free bonus mount that can come in handy. You can drill holes through it, glue it to a surface, or cut it down to size for a custom mount.

Mounting Tips:

• Drill holes into the corners and use screws to hold the plate onto wood surfaces.

• You can put some cushion (like an old mouse pad) underneath when screwing it in to reduce vibration.

• Buy some VHB 4991 adhesive and attach it to the bottom of the square for a large mounting surface.

• Shape it to match the edge of your wakeboard or kiteboard and screw it in to create a secure custom mount.

CHEAP & EASY DO-IT-YOURSELF GoPRO MOUNTS

GoPro'ers are a creative bunch who have taken underground no-frills filmmaking to the next level. Custom mounts are one of the easiest ways to get unique shots. The key is to keeping them cheap or else you might as well go buy a professionally made version. These cheap and easy custom mounts will give you a headstart on your image-making (and probably attract some interested onlookers at the same time).

EGG TIMER TIME LAPSE

The Ikea Ordning Egg Timer costs about $6 and works great for a rotating camera mount to shoot time lapse photos for video clips. You can stick a mount directly on top of the timer, set the time lapse settings and the egg timer will slowly move counterclockwise. You can't adjust the rotating speed of the timer (360 degrees in one hour), which is far too slow for regular speed video, but for $6 US, this is a great way to add some movement to your time lapse clips.

How To Make This Mount:
Simply stick a Flat Adhesive Mount to the top of the Ordning Egg Timer (from Ikea)

Mounting Tips:
• The rotation is very slow, so you will need to combine your photos into a time lapse clip or speed up your video to make the footage interesting.
• When composing your shot, look at the scene where your shot will start and end to make sure the entire clip will look good.

Mounting Example:

• SETTING USED FOR THE ACTION SHOT: Shot in Time Lapse Photo Mode at 1 photo every .5 seconds at 12 MP WIDE so the photos could be combined into a 4k video time lapse.

BACKPACK POLE MOUNT (THIRD PERSON MOUNT)

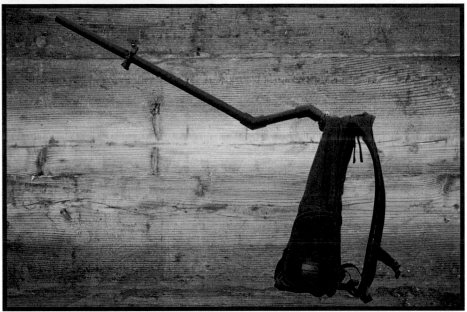

The Backpack Pole Mount creates one of the coolest angles around. Also called the Third Person Mount, this custom mount **captures a perspective of your camera following you** from behind. This mount is NOT MADE for HIGH-IMPACT activities and is not waterproof, but for leisurely activities, this mount is perfect to get a full angle of the action with you in center stage. The mount is framed into your backpack so it creates a steady shot of you as the scenery moves around you.

What You'll Need:

A Backpack

10' piece of 3/4" PVC SCH40 480psi

PVC Cutter (or cut the pieces at your hardware store)

3/4" PVC Tee

(4) 90° PVC Elbows

45° PVC Elbows

PVC Pipe Cement

Handlebar/Seatpost Mount

Black or Clear Zip Tie

How To Make This Mount:

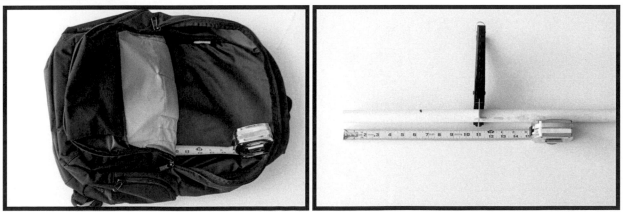

1. Measure the width and height (before your pack starts to curve) of the inside of your backpack so you can build a square

frame to fit snugly inside.

2. Cut one piece of PVC pipe that is the width of the inside of the backpack minus 2.5" to accommodate the 90° PVC Elbows. This is for the BOTTOM of the frame.

3. Cut two pieces of PVC that are the height of the interior of your backpack minus 2.5" to accommodate the 90° PVC Elbows. These are for the SIDES of the frame.

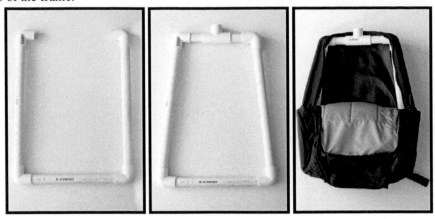

4. Put the bottom and side pieces together with the (4) 90° PVC Elbows. You don't need to glue these pieces.

5. Put the frame in the backpack and measure the distance of the empty space at the top of the frame between the two 90° PVC Elbows.

6. Cut two equal pieces that are 1/2 the measurement from step 5 minus 3/4" each to compensate for the PVC Tee that will be in the middle.

7. Add these two pieces to the top of the frame with the PVC Tee in the middle.

8. Put the frame into the backpack.

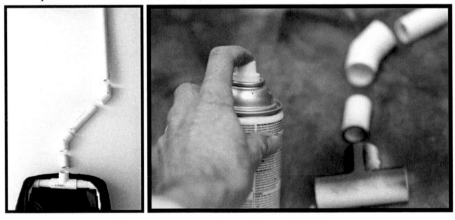

9. Cut a short piece (about 2") to attach the 45° PVC Elbow to the Tee Bar. If you need more height to reach the zipper, cut a piece of PVC that is the height from the PVC Tee to the zipper on your backpack.

Optional: Spray paint all pieces from the Tee up so that they match your backpack to make the pole less noticeable.

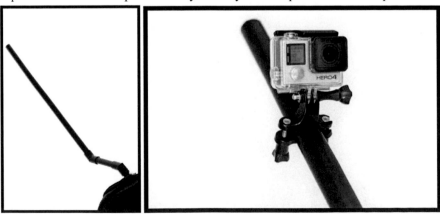

10. Attach a 5" piece to the 45° Elbow with another 45° PVC Elbow at the end.

11. Attach a 1'-2' long pole to the 45° Elbow.

12. Glue all of the pieces from the top of the Tee Bar up together using PVC Cement.

13. Attach the Handlebar/Seatpost to the end of the long pole.

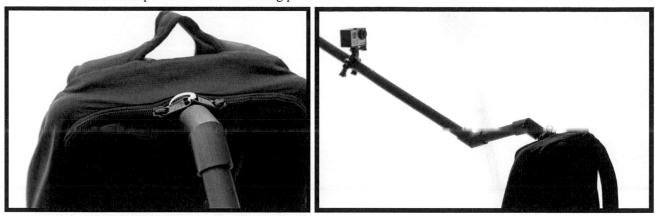

14. Zip Tie the zippers together to hold your frame securely in the backpack

Mounting Tips:

• Adjust the angle of the shot by rotating the tee at the top of the frame in your backpack.

• You can also move the Handlebar/Seatpost Mount in different areas along the end pole to adjust the distance between you and the camera.

• Use a shorter pole for activities where the long pole may get in your way, like if you are hiking through thick bushes.

Mounting Example:

<u>WHILE HIKING</u>

• SETTING USED FOR THE ACTION SHOT: 4k @ 30fps WIDE. Although a Standard Aspect Ratio 4:3 would have captured more of the scene, the desired output was for a 4k shot, so this was filmed in 4k. 30 frames per second was sufficient for the low light in the shaded areas since the clip did not require slow motion.

Available Premade Versions:

• For high-impact sports, buy a professionally made mount for safety. VuVantage makes the VuPackPole and Sail Video System makes a couple of different versions.

FOLLOW YOUR PASSION

The following diagrams illustrate some of the best mounts and mounting locations for some of the most popular adventure sports. Of course, there are more sports and activities for your adventurous lifestyle, but **these are a starting point to inspire you to get out there and start filming with your HERO4**. As you figure out which angles and locations work well for you, your ideas and knowledge will expand and even more ideas for creative mounting locations will come to mind.

All of the following setting recommendations are for Wide FOV, unless noted otherwise. The recommended settings are to provide you with an initial setting to use for each mounting position if you are just getting started. As you gain experience using your camera, **you will undoubtedly develop your personal favorite settings to film your action**.

NOTE: The recommended settings are for output to a 1080p video. If you are recording 4k, use 4k SuperView @ 24fps for most body-mounted POV shots. Use 4k @ 30fps for other shots where you have more distance between you and your camera.

WATER SPORTS

Use a Floaty Backdoor (when the mounts allow it) and follow the Anti-Fogging Technique in the Standard Waterproof Housing section for all watersports.

SURFING

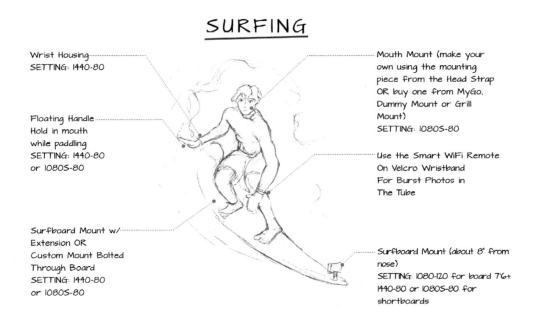

Wrist Housing
SETTING: 1440-80

Floating Handle
Hold in mouth
while paddling
SETTING: 1440-80
or 1080S-80

Surfboard Mount w/
Extension OR
Custom Mount Bolted
Through Board
SETTING: 1440-80
or 1080S-80

Mouth Mount (make your
own using the mounting
piece from the Head Strap
OR buy one from MyGo,
Dummy Mount or Grill
Mount)
SETTING: 1080S-80

Use the Smart WiFi Remote
On Velcro Wristband
For Burst Photos in
The Tube

Surfboard Mount (about 8" from
nose)
SETTING: 1080-120 for board 7'6+
1440-80 or 1080S-80 for
shortboards

STAND UP PADDLING

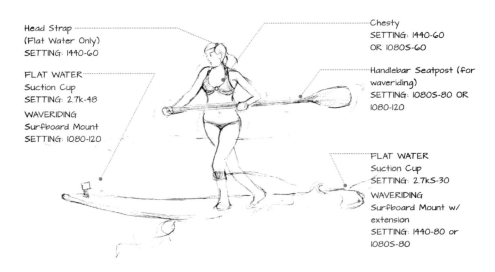

Head Strap
(Flat Water Only)
SETTING: 1440-60

FLAT WATER
Suction Cup
SETTING: 2.7k-48
WAVERIDING
Surfboard Mount
SETTING: 1080-120

Chesty
SETTING: 1440-60
OR 1080S-60

Handlebar Seatpost (for
waveriding)
SETTING: 1080S-80 OR
1080-120

FLAT WATER
Suction Cup
SETTING: 2.7kS-30
WAVERIDING
Surfboard Mount w/
extension
SETTING: 1440-80 or
1080S-80

BOATING

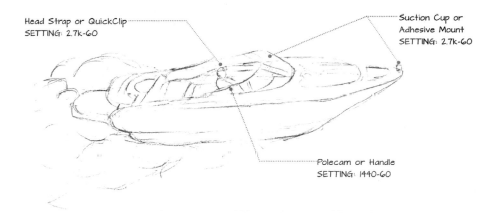

Head Strap or QuickClip
SETTING: 2.7k-60

Suction Cup or
Adhesive Mount
SETTING: 2.7k-60

Polecam or Handle
SETTING: 1440-60

SNORKELING / DIVING

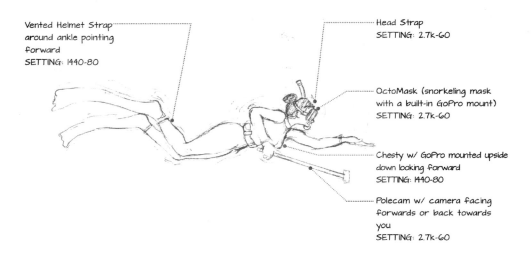

Vented Helmet Strap
around ankle pointing
forward
SETTING: 1440-80

Head Strap
SETTING: 2.7k-60

OctoMask (snorkeling mask
with a built-in GoPro mount)
SETTING: 2.7k-60

Chesty w/ GoPro mounted upside
down looking forward
SETTING: 1440-80

Polecam w/ camera facing
forwards or back towards
you
SETTING: 2.7k-60

BODYBOARDING

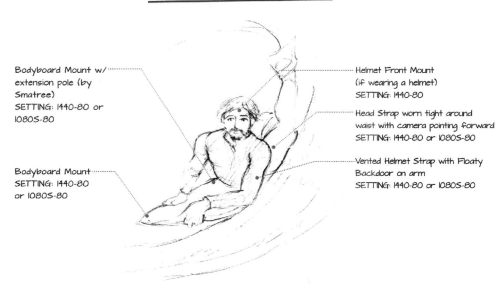

Bodyboard Mount w/
extension pole (by
Smatree)
SETTING: 1440-80 or
1080S-80

Bodyboard Mount
SETTING: 1440-80
or 1080S-80

Helmet Front Mount
(if wearing a helmet)
SETTING: 1440-80

Head Strap worn tight around
waist with camera pointing forward
SETTING: 1440-80 or 1080S-80

Vented Helmet Strap with Floaty
Backdoor on arm
SETTING: 1440-80 or 1080S-80

KAYAKING

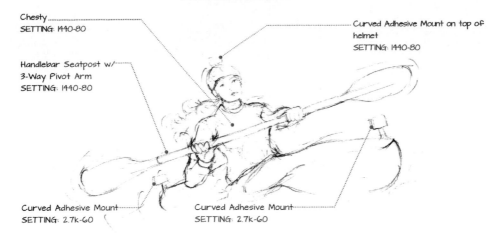

Chesty
SETTING: 1440-80

Handlebar Seatpost w/
3-Way Pivot Arm
SETTING: 1440-80

Curved Adhesive Mount on top of
helmet
SETTING: 1440-80

Curved Adhesive Mount
SETTING: 2.7k-60

Curved Adhesive Mount
SETTING: 2.7k-60

BODYSURFING

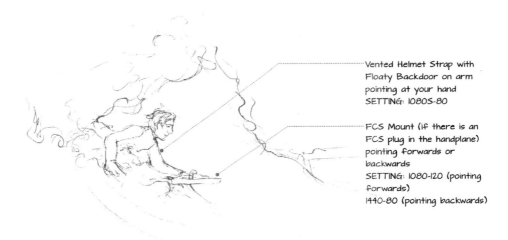

Vented Helmet Strap with
Floaty Backdoor on arm
pointing at your hand
SETTING: 1080S-80

FCS Mount (if there is an
FCS plug in the handplane)
pointing forwards or
backwards
SETTING: 1080-120 (pointing
forwards)
1440-80 (pointing backwards)

KITEBOARDING

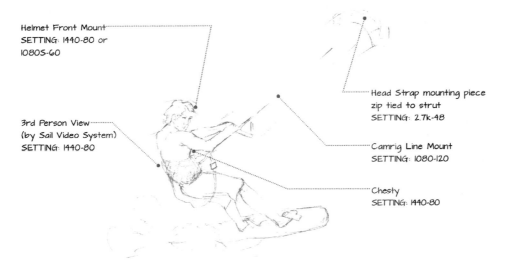

Helmet Front Mount
SETTING: 1440-80 or
1080S-60

3rd Person View
(by Sail Video System)
SETTING: 1440-80

Head Strap mounting piece
zip tied to strut
SETTING: 2.7k-48

Camrig Line Mount
SETTING: 1080-120

Chesty
SETTING: 1440-80

WINDSURFING

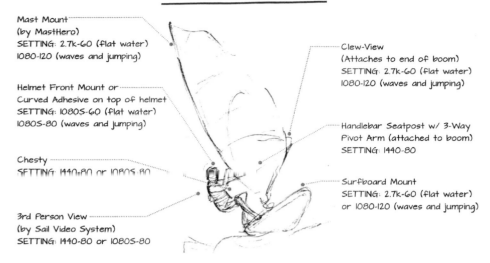

Mast Mount
(by MastHero)
SETTING: 2.7k-60 (flat water)
1080-120 (waves and jumping)

Helmet Front Mount or
Curved Adhesive on top of helmet
SETTING: 1080S-60 (flat water)
1080S-80 (waves and jumping)

Chesty
SETTING: 1440-80 or 1080S-80

3rd Person View
(by Sail Video System)
SETTING: 1440-80 or 1080S-80

Clew-View
(Attaches to end of boom)
SETTING: 2.7k-60 (flat water)
1080-120 (waves and jumping)

Handlebar Seatpost w/ 3-Way
Pivot Arm (attached to boom)
SETTING: 1440-80

Surfboard Mount
SETTING: 2.7k-60 (flat water)
or 1080-120 (waves and jumping)

WAKEBOARDING

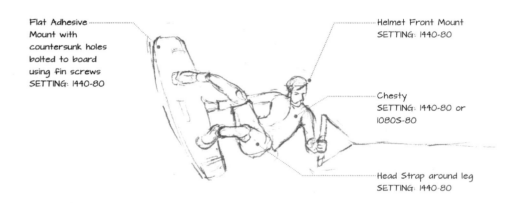

Flat Adhesive
Mount with
countersunk holes
bolted to board
using fin screws
SETTING: 1440-80

Helmet Front Mount
SETTING: 1440-80

Chesty
SETTING: 1440-80 or
1080S-80

Head Strap around leg
SETTING: 1440-80

LAND SPORTS

MOTORCYCLING

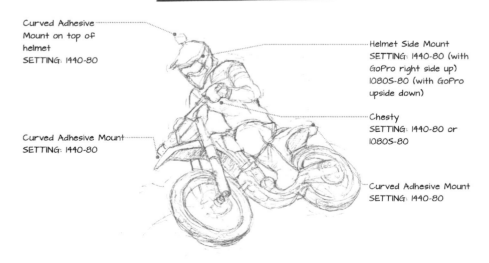

Curved Adhesive
Mount on top of
helmet
SETTING: 1440-80

Curved Adhesive Mount
SETTING: 1440-80

Helmet Side Mount
SETTING: 1440-80 (with
GoPro right side up)
1080S-80 (with GoPro
upside down)

Chesty
SETTING: 1440-80 or
1080S-80

Curved Adhesive Mount
SETTING: 1440-80

HIKING

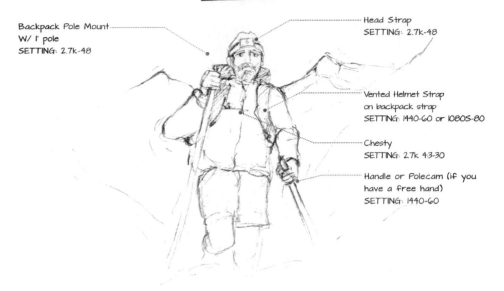

Backpack Pole Mount
W/ 1' pole
SETTING: 2.7k-48

Head Strap
SETTING: 2.7k-48

Vented Helmet Strap
on backpack strap
SETTING: 1440-60 or 1080S-80

Chesty
SETTING: 2.7k 4:3-30

Handle or Polecam (if you
have a free hand)
SETTING: 1440-60

BIKING
Mountain, BMX & Road

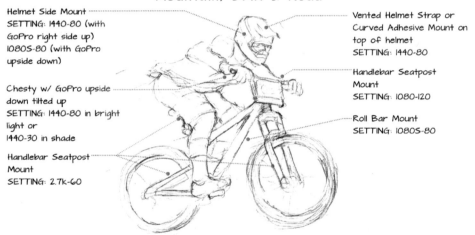

Helmet Side Mount
SETTING: 1440-80 (with
GoPro right side up)
1080S-80 (with GoPro
upside down)

Chesty w/ GoPro upside
down tilted up
SETTING: 1440-80 in bright
light or
1440-30 in shade

Handlebar Seatpost
Mount
SETTING: 2.7k-60

Vented Helmet Strap or
Curved Adhesive Mount on
top of helmet
SETTING: 1440-80

Handlebar Seatpost
Mount
SETTING: 1080-120

Roll Bar Mount
SETTING: 1080S-80

SKATEBOARDING

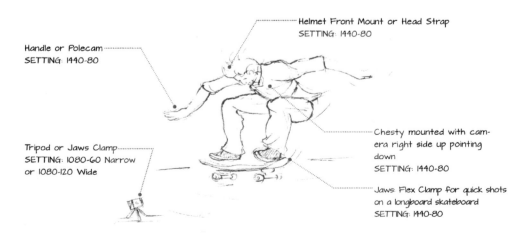

Handle or Polecam
SETTING: 1440-80

Tripod or Jaws Clamp
SETTING: 1080-60 Narrow
or 1080-120 Wide

Helmet Front Mount or Head Strap
SETTING: 1440-80

Chesty mounted with cam-
era right side up pointing
down
SETTING: 1440-80

Jaws Flex Clamp for quick shots
on a longboard skateboard
SETTING: 1440-80

ROCK CLIMBING

Head Strap or
Helmet Front Mount
SETTING: 2.7k 4:3-30

Chesty w/ GoPro upside
down tilted up
SETTING: 2.7k 4:3-30

Chesty worn backwards w/
GoPro upside down tilted up
SETTING: 2.7k 4:3-30

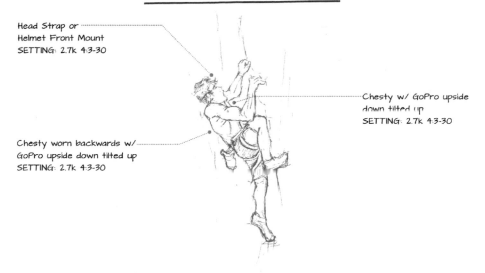

CARS & TRUCKS

Flat Adhesive Mount
SETTING: 2.7k-60

Suction Cup (on outside
of vehicle and on inside of
windshield)
SETTING: 2.7k-60

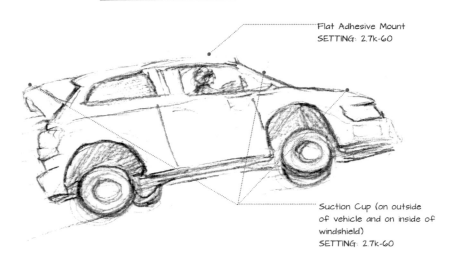

SNOW SPORTS

SKIING

Curved Adhesive Mount on
top of helmet
SETTING: 1440-80
or 1080S-80

Handlebar Seatpost
Mount on ski pole. Hold
in front or behind you
for selfie.
SETTING: 1440-80
or Time Lapse Photos
@ 1 photo/.5 second

Helmet Front Mount OR
Head Strap over helmet
SETTING: 1440-80
or 1080S-80 (looking
forward)

Head Strap Mount (with top
strap removed) around boot
SETTING: 1080-120

Chesty (with camera right
side up)
SETTING: 1440-80
or 1080S-80

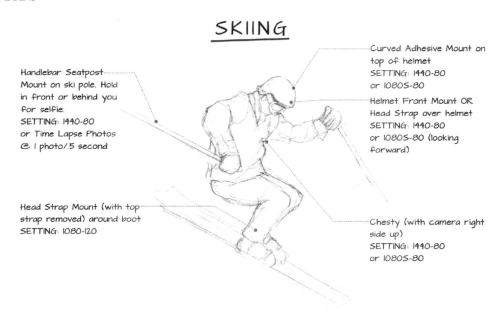

SNOWBOARDING

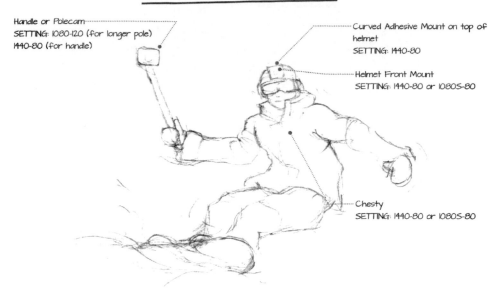

Handle or Polecam
SETTING: 1080-120 (for longer pole)
1440-80 (for handle)

Curved Adhesive Mount on top of helmet
SETTING: 1440-80

Helmet Front Mount
SETTING: 1440-80 or 1080S-80

Chesty
SETTING: 1440-80 or 1080S-80

AIR SPORTS

PARAGLIDING

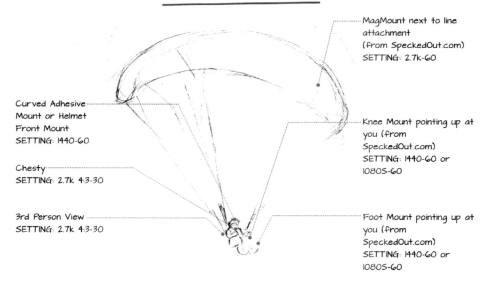

MagMount next to line attachment
(from SpeckedOut.com)
SETTING: 2.7k-60

Curved Adhesive Mount or Helmet Front Mount
SETTING: 1440-60

Knee Mount pointing up at you (from SpeckedOut.com)
SETTING: 1440-60 or 1080S-60

Chesty
SETTING: 2.7k 4:3-30

3rd Person View
SETTING: 2.7k 4:3-30

Foot Mount pointing up at you (from SpeckedOut.com)
SETTING: 1440-60 or 1080S-60

SKYDIVING

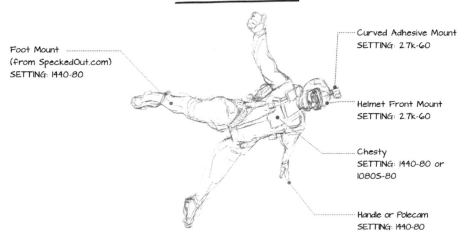

Foot Mount
(from SpeckedOut.com)
SETTING: 1440-80

Curved Adhesive Mount
SETTING: 2.7k-60

Helmet Front Mount
SETTING: 2.7k-60

Chesty
SETTING: 1440-80 or 1080S-80

Handle or Polecam
SETTING: 1440-80

HANG GLIDING

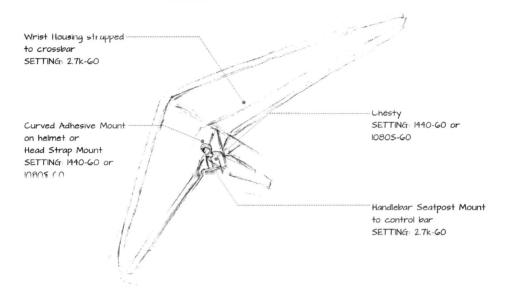

Wrist Housing strapped
to crossbar
SETTING: 2.7k-60

Curved Adhesive Mount
on helmet or
Head Strap Mount
SETTING: 1440-60 or
1080S-60

Chesty
SETTING: 1440-60 or
1080S-60

Handlebar Seatpost Mount
to control bar
SETTING: 2.7k-60

NOW THAT YOU'VE GOT YOUR CAMERA MOUNTED, YOU ARE READY TO MOVE ONTO STEP 3 TO LEARN SOME VITAL PHOTOGRAPHY AND CINEMATOGRAPHY KNOWLEDGE!

STEP THREE
CAPTURE YOUR ACTION

Learn These "Not-So-Secret" Photography Secrets & Get Results

Now that your camera is set up and ready, it's time to hit that record button. Whether you are shooting video or photos, there are a few important elements that are (almost) always part of a memorable photograph or video. The shooting tips in this step will help you capture the footage you know your HERO4 is capable of- the kind of immersive, exciting video that motivated you to get your camera in the first place.

TELL A STORY

When you are thinking about different shots for your video, remember that you want to tell a story. If you want to make a video that grabs your viewers' attention, **start thinking about your video before you are out there in action**. The best GoPro videos inspire us and motivate us to go adventure by telling a story, showing the action, and leaving on a high note.

Film the Prep

Instead of just recording the main activity, film the preparation- show the beforehand when you are getting your gear ready for the adventure or a pulled back shot of you leaving for your destination. Film a close-up in a Narrow FOV when you are putting on your gear or prepping your important equipment.

Record The Action

This is where you can record some or all of the angles shown in this book of the main activity. This is where you show off your skills with high action shots or beautiful scenery.

Make The Angles A Mystery

When possible, try to **film multiple angles without seeing any other cameras** in the scene. This keeps the viewer involved in the action, not in the filming techniques.

Close With A Bang

Close your video with a dramatic POV shot that leaves your viewer wanting more, or better yet, wanting to go out there and do what you are doing- having fun!

LIGHTING

In the eyes of most photographers and videographers, lighting is everything. Sometimes the radical action captured with point of view cameras can overpower less than optimal lighting, but good lighting ALWAYS makes a shot look better.

Figuring out lighting with your mounted camera is especially tricky because you have to foresee how your lighting will be when

you are filming. The way you see light in your footage changes dramatically depending on how you mount your camera and the angle you choose to shoot.

When you are preparing for your adventure, think about where the sun will be and what direction you will be facing during the most important times. Then consider what lighting scenario you want for your shot. When using GoPro® cameras, there are so many mounting techniques that there is almost always an angle that will capture the lighting you desire.

Wearable mounts offer the least amount of flexibility in regards to where you point your camera. A handheld polecam offers the most flexibility because you can adjust your angle to compensate for different lighting scenarios.

Here are some lighting situations you will come across:

The Golden Hour (Aka the Magic Hour in cinematography)

The Golden Hour refers to the hour around sunrise and sunset.

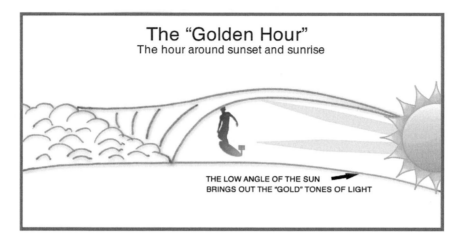

During this time, **lighting is softer and warmer**. Shadows are lighter and also longer which can make for a dramatic effect. Sometimes, it can be difficult to keep your own shadow out of the shot during this time, but the results of shooting during these times usually pay off big time. Because the light is not as bright during the Golden Hour, follow the recommendations for "Low Light Situations" at the end of this Lighting section.

Front Lit Lighting

Front lit lighting is when the light from the **sun is on the subject's face** and the camera is between the sun and the subject. Front-lit lighting tends to make for the bluest skies and best scenic colors, but it also causes shadows on people which can sometimes be less than flattering.

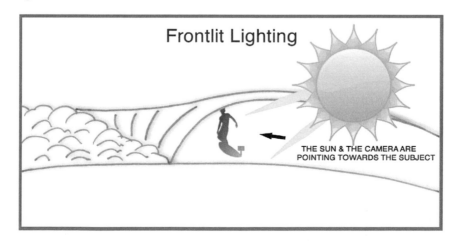

Front lit lighting is the rule that most of us have heard at least once and probably 100 times. "Have the sun behind you when

you take a picture!" Front lit is one of the best ways to light a photograph. Depending on the orientation of your scene, front lit lighting can occur either through the morning or the evening hours.

Backlit Lighting

Backlit lighting is when the **sun is behind the subject**, usually causing the subject to be too dark against a bright background.

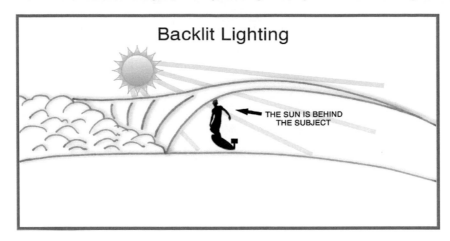

There are positive aspects of backlit lighting though. One is that there are no shadows on a person's face, which means a lot of portraits are taken during backlit conditions. Backlit photos in waves also bring out those green, moody photos where the light is shining through the water. This happens in the tube of the wave, so if you can get yourself in the right spot, the results can be beautiful.

The problem with filming backlit lighting with a GoPro® camera is that the camera will take a "correct" exposure reading which often makes the subject too dark. To correct the exposure on your subject when backlit, you have to override the camera so that it overexposes the image (makes it brighter than the camera thinks it should be). See the next section on Exposure to learn how you can manually override your camera's exposure reading.

Cloudy Lighting

Cloudy lighting is exactly like it sounds-capturing footage when there is no distinct angle of the sun because the **light is being diffused by the clouds**.

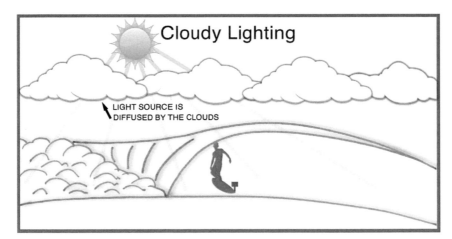

Most of the time, filming when it is cloudy gives the footage a "white" look to it, so filming in cloudy conditions is not optimal lighting. The footage won't have the same richness and color as a sunny day, but certain shots work well in cloudy conditions.

Because cloudy lighting doesn't have shadows, you can still capture usable footage if you are filming an activity that would otherwise be going in and out of shadows, like skateboarding through a city or mountain biking through trees.

High thin clouds are A LOT different than grey clouds. High, thin clouds add nice texture in the sky without diminishing the light, so if there are high clouds in the sky, go for it.

Midday Lighting

Midday Lighting is **when the sun is nearly directly overhead**, which actually happens for a relatively long period throughout the middle of the day.

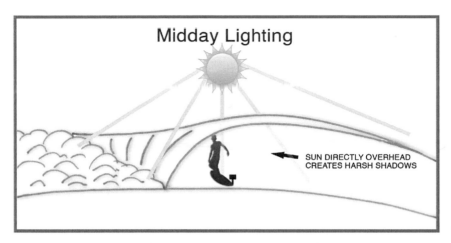

This is undoubtedly the worst option by almost all photographers' accounts. Harsh sun usually produces washed out colors and a lot of shadows. The best thing to do during midday lighting is to film in complete shade. Or with a point of view camera, you can change the angle to minimize the harsh shadows of the midday sun. A helmet-mounted position looking down works well for midday lighting.

One exception is in the ocean where the water is really clear, like in Australia, the Caribbean or Hawaii. You can actually use the midday sun's rays to your advantage in clear water because those rays create some really cool effects underwater and bring out the blue shades of the water.

Low Light Situations

Filming in low light situations (early morning, evening, cloudy or shady), will often create blurry photos or videos.

For the best results when you are recording video **in low light situations, lower the frame rate to 24 or 30 frames per second**. This lower frame rate allows your camera to take in more light for each frame, resulting in better quality footage. The higher frame rates (48FPS and higher) are better suited for normal daylight.

When taking photos, avoid taking Burst Photos in low light situations because your subject will often be blurred. In the other photo modes, try to keep your camera as stable as possible when you press the Shutter Button.

You can **use the low light to your advantage** to create a cool, blurred background effect. To obtain your subject in focus with a blurred background using Burst or Time Lapse photo modes, keep the primary subject stationary in relation to the camera and create movement in the background. When you are recording in low light situations, the camera will not have enough light to keep the moving objects in focus. This will give your photos the blurred background effect. This technique works specifically well and looks really eye-catching for time lapse sequences and burst sequences.

EXPOSURE

Exposure refers to the amount of light that is let into your camera during recording. "Correct" exposure is usually a balance

between overexposed (where there is a loss of detail in the bright, highlighted, areas) and underexposed (where there is a loss of details in the darker, shadowed areas). Getting correct exposure is easiest to capture in front-lit or sometimes cloudy conditions. If you are shooting in other lighting conditions, in most situations, you will want to adjust exposure in editing software after you film.

The HERO4 Black camera sets exposure automatically and you only have limited control over the exposure reading. There are no shutter or aperture controls for daylight filming, so for the most part, you have to go with the exposure reading from the camera. However, there are **two ways you can affect the exposure**. One way is to **turn on Spot Meter for tricky lighting conditions** as mentioned in Step 1- Settings. The second way to affect exposure is to **use Exposure Value Compensation** when Protune is turned on. You can adjust the exposure by telling the camera to make your video or photos up to two stops brighter (+2) or darker (-2).

ACTION

For GoPro® camera users, the action often speaks for itself. Unlike traditional photography, you've already chosen your angle by the way you mounted your camera. Now it's time for you to get some great action in front of your lens. The more intense the action, the better the results.

When filming, remember to **keep your camera steady and let the action create the movement**. With video shots, a steady camera helps create footage that is easy on the eyes- too much shaking in your hands and it becomes hard to watch.

When taking photos, a steady camera helps ensure that your photos will come out "sharp" and in-focus.

For editing purposes, it's easier to **turn the camera off in between "action" moments**. You can also **utilize HiLight Tagging** as described below. If it's too hard to reach your camera or your activity doesn't allow it, you can film continuously. It just means you will be searching through longer clips of footage later to find those "WOW" moments.

HiLight Tagging

Finding your magic moments during a video clip can send you on a long search through your files. The engineers at GoPro have attempted to tackle this problem by adding a new feature called HiLight Tag to the HERO4 cameras.

When something memorable happens while you are recording video, press the Settings/Tag Button on the side of your camera. Pressing this button during recording will add a HiLight Tag. Adding a HiLight Tag does not affect your video footage or add anything visible to the video.

You can also add a HiLight Tag when playing back your video using the LCD BacPac by pressing the Settings/Tag Button. HiLight Tags can also be added while recording with the GoPro App or the Smart WiFi Remote.

When you go to edit your video in GoPro Studio or the GoPro App, you can see the HiLight Tags on the video timeline so you know exactly where to go to find your magic moments.

FILMING TECHNIQUES

It's not really necessary for a recreational filmmaker to know the names of the various filming techniques, but an awareness of the various techniques will inspire you to add more flair to your videos. When you watch videos that inspire you, pay attention to what techniques the filmmaker used to make the video stand out and make an impression.

Since most recreational GoPro users don't have expensive filming equipment, it's best to **make do with what you already have** to mimic these techniques in the grassroots do-it-yourself GoPro style everyone loves.

Tilt Shot

This technique is like **looking up and then down** or vice versa. To film a tilt shot, point the camera up and then down by rotating it on its horizontal axis. This shot is typically filmed using a tripod. You can use the Tripod Mount to mount your HERO4 on a tripod if you are looking for a professional looking shot.

If you don't have a tripod or are on the go, you can **mimic a tilt shot** by holding your HERO4 camera with two hands and smoothly tilting the camera from top to bottom or vice versa.

Pan Shot

A pan shot is similar to the tilt shot, except, instead of moving the camera up and down, a pan shot is **filmed in a side-to-side motion**, rotating the camera on its vertical axis from left to right or vice versa. This technique is like looking left and then right. For eye-catching shots, rotate your camera from an empty scenic shot towards your subject, bringing your subject into the frame. Also, adding a panning motion to time lapses (using the Egg Timer) adds a nice touch of movement.

Dolly

A dolly shot is typically filmed with the camera mounted on a camera dolly, moving the **camera towards or away from the subject**. You can mimic this technique without using a real dolly by holding your HERO4 steady while moving your camera slowly towards or away from your subject. This filming technique looks great with stationary subjects for intros to a video.

Tracking Shot

In a tracking shot, the camera moves from left to right or vice versa, keeping the camera on the same axis to **move parallel with the subject**. A great way to mimic this technique with your HERO4 is to hold the camera upside down on a pole or handle while riding a bike or skateboarding alongside your subject. The goal is to create smooth movement that moves with your subject. Include foreground objects in the shot for a real sense of movement.

Follow Shot

In a follow shot, the camera **physically follows the subject at a (more or less) constant distance**. You can capture this angle of yourself by mounting your HERO4 on an extension to the back of your equipment, vehicle, etc. You can also ride behind someone on a skateboard, bike, snowboard or surfboard and follow your friend. For a steady shot, **use a polecam with your camera upside down** like shown in the Follow-Along Angle of the Handle / Polecam section.

CAPTURING USABLE AUDIO

The HERO4 is able to record usable audio even when the camera is in the waterproof housing with the waterproof backdoor. Although there are no openings in the waterproof housing case, the camera's Auto Gain Control automatically adjusts the audio recording level. However, when your camera is in the sealed waterproof housing, the sound tends to be a bit muffled.

If your camera is NOT at risk of getting wet during filming, you can **capture better audio by using the Skeleton Backdoor** with the waterproof housing. The waterproof housing provides a wind barrier if you are in action, but the holes in the Skeleton Backdoor allow more audio capture.

The Frame is also a great option for recording usable audio in windless or calm situations, for example, when you are recording your children playing in the yard or when your camera is mounted to an instrument.

There is also an input to use an external microphone if high quality sound is extremely important to the shot you are filming. See the MICROPHONE section in Step 6- Take It Further for more info on using an external microphone.

UNDERSTAND YOUR LENS

GoPro® cameras come with a Fisheye Wide Angle Lens built in. What does this mean? A fisheye lens is **an ultra wide-angle lens that allows more of the scene to be included in the frame**. In video modes, the HERO4 lens has a range of view from Narrow to Medium to Wide. At the widest angle, fisheye lenses can cause some curvature of whatever is around the edges of the frame.

Fisheye Wide Angle Lenses are perfect for point of view cameras for several reasons:

1) They **can be mounted extremely close to you** and still capture you in the image.

2) They have a short depth of field, which means **everything that is about 12 inches from the camera and beyond will be in focus**. (See Step 6 for more about Macro Lenses if you want to film objects closer than 12 inches) This is great because you don't have to focus the camera.

It is important to understand the best techniques for using a fisheye lens because it is an art in itself.

Here are some vital tips:

1) **GET CLOSE!** If you aren't close to whatever you are filming, the subject will be very small in the frame. You know how some rear-view mirrors on cars say "Object May Be Closer Than They Appear". The same is true with fisheye lenses because they distort the perspective to make things look smaller than they do with the naked eye. Remember this and **get closer to your subject than you think you would need to.**

2) The middle of the frame has the least amount of distortion, so **frame your images with the distortion in mind**. If the horizon is towards the top of your frame, it will have that curved appearance.

3) Use the foreground to your advantage. By having some sort of object near the foreground, it will **give your image more depth**. Your arm, helmet, board, or foot make good foreground objects to create that sense of perspective.

4) **Work with the sky,** instead of against it. Because wide angle lenses capture so much in the frame, high clouds and sunset colors in the sky add a lot of drama to a scene.

Distance Away To Get A 6' Tall Person Full Frame

Since there is no built-in viewfinder on the HERO4 Black, it is helpful to have an idea about how far away you need to be from your subject to get your full subject in the frame. These are the minimum distances for a 6' tall person to be full frame in the various fields of view. To achieve this, aim your camera towards the middle of your subject. Of course, you do not need to have your subject full frame, but this guide will give you an idea of what you are capturing at specific distances.

16:9 Widescreen Resolutions (4k, 2.7k, 1080p, 720p, WVGA):

FIELD OF VIEW	DISTANCE TO SUBJECT FOR FULL FRAME
WIDE	4' (1.2m)
MEDIUM	6' (1.8m)
NARROW	10' (3m)

Standard Modes (2.7k 4:3, 1440p, 960p and all Superview resolutions):

FIELD OF VIEW	DISTANCE TO SUBJECT FOR FULL FRAME
WIDE	2'6" (.75m)

PUSHING THE SHUTTER

One last thing when it comes to capturing the action is that when shooting photos, the camera **beeps after the camera has processed the image, not when the camera takes the image**. Because of this many people understandably think that there is a delay. But in Single Photo Mode, Continuous Photo Mode and Time Lapse Mode, your **camera actually takes the photo as soon as you press the shutter button**. So, you can really just ignore that delayed BEEP and press the shutter button when you see the action. In Burst Mode, there is about a .5 second delay between when you push the Shutter Button and when your camera begins taking photos. In Night Photo and Night Lapse Mode, there is about a 2 second delay.

When shooting self-portrait action photos in the Burst Mode, the Smart WiFi Remote is especially useful. With video, you can record continuously during the action, but with self-portrait action photos, you need to push the Shutter Button at the exact right moment. The remote can also be used in Continuous Mode to take photos for as long as you hold down the Shutter Button. For more WiFi Remote tips and ideas, see the WiFi Remote section in Step 6- Beyond the Basics!

ACTION SEQUENCE TIPS

An action sequence is made by **editing together multiple photos to show your subject moving across the photo**. When shooting a photo sequence with the goal of creating an action sequence, **set up your shot so that your subject moves across the frame**. Pull back your camera a bit from the subject so that your subject can enter the photo on one side of the frame and exit on the other side of the frame. You need to have enough side-to-side distance so that you can have a few different images of your subject without overlapping.

For the easiest editing, **set your camera up on a tripod** or propped up on the ground so that the scene remains the same and your subject is the only thing that moves.

In Burst Mode, there is about .5 second lag time between when you push the shutter button and when your camera takes the photo, so push the Shutter button a little before the action to get your subject in the frame.

Even when you are recording fast action, such as running, jumping, skateboarding, biking, snowboarding, etc, you can usually **spread out the sequence to take 30 photos over 3 seconds**, unless the action is really fast.

For Burst Mode photos, you will need to **film in bright daylight** to give your camera enough light to take sharp photos. If you find that your photos are turning out blurry, the most common problem is that there is not enough light for your camera to shoot such a fast sequence without getting blurred shots.

For **slower action**, such as walking, **set your camera on Time Lapse Mode** at one photo every .5 seconds. This will ensure that your camera continues shooting until your subject has completely crossed the frame.

See Step 4- Editing An Action Sequence for step-by-step instructions on how to put together your own action sequence.

TIPS TO EXTEND BATTERY LIFE

The HERO4 uses a rechargeable lithium-ion battery. Unlike NiCad batteries, Lithium batteries don't have a memory charge, so **recharging your battery even if it is not completely drained will not reduce the battery life**. Like all lithium-ion batteries, the battery in your HERO4 will eventually lose some capacity over time, so a fresh battery may be your best bet if you notice that your battery is not performing like it used to.

Follow these additional tips to preserve your battery's life:

• **Store your camera at a normal room temperature** when possible. Try to keep your battery out of extreme heat, especially when it is fully charged. Keeping your camera (with the battery in it) in a hot car will deteriorate your battery's capacity.

• If you need to store a spare battery for an extended period, use it until there is about 40% battery life remaining (about one or two bars on the battery life indicator symbol) and store the battery in sealed bag in the refrigerator.

There are several things you can do to preserve battery life while actively using your HERO4:

• If you know you won't be filming for a while, **turn your camera off to save battery**. Your camera will go into standby mode after about five minutes of inactivity. This standby mode greatly reduces the amount of battery that is being used. But if you know you won't be filming for a while, it's easy to hold down the Front/Power button and turn off your camera so that it doesn't use any of the battery life.

• **QuikCapture Mode reduces any standby time** by turning your camera on and recording with one push of the button. There is a delay however while you wait for your camera to turn on, so QuikCapture Mode doesn't work for all filming scenarios.

• Turn off the WiFi if you are not using it. The WiFi uses some battery power to create the wireless signal. Keeping the WiFi on is worth the reduction in battery life as long as you are using the WiFi Remote or the App. But, if you are not using either of those, turn off the WiFi by holding down the button on the left side of your camera.

• If you are using the LCD BacPac, this accessory uses up a good chunk of battery. If you are primarily using the LCD BacPac to set up your shots, **turn the BacPac off after you have composed your angle** and tightened your camera in place.

NOW THAT YOU HAVE THE KNOWLEDGE TO CAPTURE YOUR FOOTAGE, GET OUT THERE AND START FILMING! IN STEP 4, YOU WILL LEARN HOW TO EDIT YOUR PHOTOS, VIDEOS AND TIME LAPSE CLIPS.

CREATION

Now Is The Time To Put It All Together

So, now you've got the footage! This should be the exciting part and with our help, it will be! Creating your edited product is where a lot of GoPro® camera users get lost and this is why so many people have thousands of unedited photos and hours of uncut footage stored on their hard drives. But it should be where you get excited because this is where you get to create! Follow this advice and you will soon be able to show everyone how much fun you are having and encourage them to get out there too!

BEFORE YOU START EDITING

Video Editing Software

The first three tutorials in this chapter, Editing Your Video, Editing a Time Lapse Video and Pulling Frame Grabs, use GoPro's free editing software called GoPro Studio. You can download GoPro Studio from GoPro's website at gopro.com/support under Software + App. This software works for Mac and PC.

If you have any problems running the software, or with the software crashing, make sure your computer meets the minimum operating requirements, is running the current operating system, and has plenty of hard drive space. If you continue to experience any problems, call GoPro's support line and they will help you troubleshoot any problems.

Photo-Editing Software

The last two tutorials, Editing Your Photos and Editing an Action Sequence, use Gimp, which is free photo-editing software for Mac and PC. Gimp is open-source software and you can download it from www.Gimp.org.

TRANSFERRING FOOTAGE TO YOUR COMPUTER

To begin viewing and editing your GoPro footage, you need to transfer your videos and photos from the micro SD card in your camera to your computer. You can use a micro SD card reader, or if you don't have a card reader, you can **transfer the files using your camera by following the steps below**.

Note: If you are having problems locating your micro SD card when your camera is connected to your computer, remove the card from your camera. Insert the card into the adapter and insert the adapter into the SD Card slot on your computer. Then, begin at Step 3.

Step 1: With your camera turned off, connect your camera to your computer with a USB cable. You will see a red LED light once it is connected.

Step 2: Turn your camera on by pushing the Power/Mode button.

Step 3: Locate your camera's micro SD card on your computer.

<u>To find your SD card on Windows:</u> Click on the Start Menu in the bottom-left corner of your screen, then click on "Computer" (On Windows XP, click on "My Computer"). Find the section named "Devices with Removable Storage" in the window that opens. Your SD card will be in that section, and it will usually be named something like "Removable Disk (E:)" or "Removable Disk (F:)"

<u>To find your SD card on a Mac:</u> Click on the Finder icon in the left side your Dock to open a Finder window. On the left, you'll see your SD card listed under Devices. If Devices are hidden, click "Show" to the right of Devices. It will usually be listed as "NO NAME" or "UNTITLED".

Step 4: Double-click on your SD card to see the folders it contains. You should see two folders: DCIM and MISC. Double-click on the DCIM folder. In that, you'll see a folder named 100GOPRO. (Note - if you took more than 9999 pictures or videos, you'll see additional folders named101GOPRO, 102GOPRO, etc.)

Step 5: Transfer your pictures and videos from your camera's memory card to your computer by clicking on the 100GO-PRO folder (and any additional folders-101GOPRO, etc.) and dragging it to your Desktop or another location on your computer where you want to keep your GoPro video and photo files.

Step 6: View your transferred pictures and videos. The pictures and videos you transferred will be in the 100GOPRO folder on your computer. Photo files end in .jpg and video files end in the extension .mp4. You can double-click on a video or photo to view it. (If you are experiencing choppy video playback, refer to the troubleshooting section at the end of this book for solutions.)

Step 7: Now you are ready to start editing.

<u>Go Deeper</u>

THM & LRV FILES

Depending on what camera resolution you are recording video in, you may notice .thm and .lrv files in addition to the full .mp4 video file.

The **.thm file** is used for displaying a thumbnail image of your video file.

The **.lrv file** is a low resolution video file which is necessary to support the Copy, Playback, and Share functionality in the GoPro App. If you are not using the GoPro App, you can erase these files if you wish to.

DELETING FILES

In order to prevent the accidental loss of files, your micro SD card is set as Read-Only. When your camera is plugged into the computer with a USB cable, you can copy your files from your camera into your computer's hard drive, but you do not have the ability to delete files from the micro SD card. Instead, if you want to format (erase all files) from the micro SD card, you can use one of the following options:

Use the Trash Can icon on the camera

1. After you have copied the files from your camera to your computer, scroll through the modes by pressing the front Power/Mode Button until you reach the Setup Menu icon.

2. Navigate to the Trashcan icon.

3. To erase all of the files on your micro SD card, select the All/Format option.

Use an SD card reader

If you have an SD card reader, you can delete files from the SD card or add files to the microSD card using a microSD/SD card reader.

Use the GoPro App

You can copy and delete files using your smartphone or tablet.

1. With your camera's WIFI enabled and connected to the GoPro App, select the GoPro Media Icon in the App.

2. Select Edit and then select the files to either copy or delete.

EDITING YOUR VIDEO

This is one simple way to edit your footage. There are lots of options when it comes to video editing. But the goal of this section is to help you get your first edited clip of footage using FREE software and to understand the basics of video editing.

This video editing tutorial uses GoPro Studio, which is GoPro's editing software, because it produces smooth slow motion and allows you to combine clips, music and titles all within one program. Alternatively, you can use iMovie (Mac) or Windows Live Movie Maker (PC), but conforming your videos for slow motion in these programs deinterlaces the file, which means frames are removed and the slow motion won't appear as smooth.

Here are some tips when you first start to think about how you are going to edit a clip:

• Have a vision for your finished product. If you plan to put together a video, create a storyboard or timeline to plan ahead and look for the pieces you need.

• Bookmark your edit worthy moments. If you weren't able to use the HERO4's HiLight Tagging feature while you were recording, make a log of the time code where your action moment take place. That way you won't have to look through hours of "in between" time for the clips you want to use.

• Erase files as you go. If you look through a video clip and see that there is nothing usable, erase it as you go. You will have lots of files to sort through, so the more you can thin out your library, the easier it will be to find your usable clips.

Follow these step-by-step instructions to create your first edited GoPro video:

#1- Select the Video Files To Use

After transferring the GoPro files to your computer, sort through your footage for two or three video clips you want to use for this tutorial.

#2- Select Desired Clip, File Size and Playback Speed

1. Open GoPro Studio

2. In the blue dialog box on the left, click Import New Files and select the video files you would like to use for this tutorial.

3. Save your project as you go along by clicking File>Save Project. Saving often will prevent you from losing any work if the program unexpectedly quits.

4. Click on the first clip you want to edit to bring it into the editing window.

5. If you recorded the clip upside down, you can push the Rotate/Flip box to automatically flip your footage right side up.

6. Search through the clip by pushing "Play" or by sliding the timebar to find the "WOW" moment you want to extract.

7. Click on the "Mark In Point" below the video frame to choose where you want your clip to start. You can push pause at the exact frame you want to start with and then push the Mark In symbol. This will leave off anything before that selected point.

8. Play the clip or slide along the timebar and click on the "Mark Out Point" at the point where you want to end the clip. This will leave out everything after that point.

9. Click on "Advanced Settings" on the bottom left below the video clip.

10. Under "Advanced Settings", there are three settings you should adjust.

 a. Choose Image Size (for now, you can leave it at the same size it was shot).

> **T**IP: If you change the image size, make sure to keep it in the same aspect ratio as it was filmed. Otherwise, GoPro Studio will stretch the video to make it conform to the other aspect ratio. If you prefer to crop your clip to a 16:9 Aspect Ratio, you can crop your clips in Step 2 of GoPro Studio (Read on to learn how to crop).

 b. Frame Rate. If you want the clip to play at normal speed, you can keep it at the original frame rate. If you want the clip to play in slow motion, this is where you make it happen by choosing a slower frame rate than what you shot the footage at. If you recorded at a high frame rate and want your video to play in slow motion, try to avoid going below 24(23.98) FPS if possible. There are more advanced methods (like using Flux which you will learn about shortly) to produce super slow motion clips from footage recorded without a high frames per second rate.

> **T**IP: You can also adjust the playback speed of the video in Step 2, under Video, but changing the frame rate in Step 1 is a more precise way of making sure your video is playing at 24 FPS.

 c. Quality- Depending on how you plan to display your clip, you should choose Medium or High.

11. Save your new clip as a new file name in the empty white box below the frame.

12. Click the blue "Add Clip to Conversion List" at bottom right.

13. Repeat steps 4-10 with the other clips you want to put in your video.

14. Click "Convert" at the bottom right.

#3- Edit the Appearance of the Individual Clips

1. Click on "Proceed to Step 2".

2. When the program asks you to choose an edit template, choose "Blank Template" and click the blue "Create" button. "Step 2 Edit" on the top bar should now be highlighted.

3. In the box on the left, click on the first clip you just converted to bring it into the editing window. When you have the clip on the left highlighted, any edits you make will be to that clip.

4. Scroll down the tool bar on the right side and under Image, you can adjust Exposure, Contrast, Saturation and Sharpness. Be careful not to get too carried away because too much of these can make your image look doctored, especially when using the Saturation slider. You can also try out GoPro Studio's presets (like ProTune or 1970s for example) on the very bottom of the bar.

5. Under "Framing Controls", you can adjust Zoom, Positioning and other options. Try these out for your knowledge and see if any of them improve the look of your clip, but be aware that zooming in can reduce the quality of your edited footage.

> **TIP:** If you shot your footage in a 4:3 Aspect Ratio (2.7k 4:3, 1440p or 960p), you can use the "4x3 to Wide" preset which will give your footage a similar look to a SuperView shot. This does not crop your clip, but rather scales and stretches it to make it fit into a Widescreen 16:9 Aspect Ratio. If you would prefer to crop your video to make it fit Widescreen without the distortion of the 4x3 to Wide preset, drag the clip to the storyboard to preview it in a Widescreen Aspect Ratio. Then, in the Framing dialog box, adjust the Vertical slider until you are happy with the cropping.

6. When finished editing the Appearance of your clip, move on to the next clip until you are happy with the appearance of the clips.

#4- Combine Clips, Add Music and Put Together your first Movie

1. To combine your clips, select each clip from the box on the left and drag the clips in the order you want them into the storyboard below. Drag them to the right of the video camera icon (where it says "Drag Video Here"). You can rearrange the order by dragging the clips in the storyboard.

2. If you find the clips are too long or have unnecessary parts, you can fine tune the start and stop points for each clip from within the storyboard by using the Mark In and Mark Out Points button.

> **TIP:** After dragging your clip into the storyboard, split the clip and speed back up certain parts to create more exciting action. Find a point of the clip where you want to speed back up the action and click on the "Split Clip at Current Position" button (to the left of the "Mark In Point" button) to split the clip. This will split the clip into two pieces. Then, click on the portion of the clip you want to speed back up, and in the Video dialogue on the right side, adjust the speed. The following percentages will bring your clip back to normal speed if you converted it to 24(23.98) FPS in Step 1. 200% for video originally shot at 48 FPS. 250% for video shot at 60 FPS. 500% for video shot at 120 FPS. By speeding up certain parts, you can make the slow motion parts more dramatic and impactful.

> **TIP:** You can play your video in reverse by clicking on the "Reverse" box under the Video dialogue. To make it exciting, drag a clip into the storyboard twice and play the second one in reverse so the action plays back on itself.

3. Add transitions in between the action clips for a more professional look. Click on the "+" sign in between each clip to change it from a cut to a dissolve. (iMovie and Windows Live Movie Maker offer more transition options).

4. Add some titles to the beginning and end. Click the "+ Title" icon at the top of the left bar. When you click on the title "clip" that you just added in the bar to the left, you change the title text and appearance on the right side. Fill in the text in the preview box on the right to give it a title (Snowboarding Chile, e.g.). Once you are happy with the words and appearance, you can either: Drag the title "clip" onto the Video bar in the storyboard before the first clip for it to be a title screen on its own OR Drag it into the Title bar on the storyboard for it to show up over the video clip.

5. Add music to create the mood. At the top of the box to the left, click the Media icon to the left of the "+Title" icon. Add a song from your computer and drag the song into the Audio bar of the storyboard. You can adjust the length of the song by clicking on the song in the storyboard and dragging the end to match the end of your video clips. If you don't want the original audio from the video clips in the background along with the music, you can click on the audio icon that is on the video clip thumbnail in the storyboard to turn off the clip's audio.

6. Press the Spacebar to preview your edited movie and make any changes.

7. When you are happy with your edited video, click on Step 3: Export. This will bring up the export dialogue. If you edited a Widescreen 16:9 video, under the Presets, select HD 1080p or HD 720p and export the finished video. To export 4k video (for footage recorded in 4k), select Custom and under Image Size, select 4k. To export video at a Standard 4:3 aspect ratio, under the Image Size tab, select Source. You now have your first GoPro® video clip!

> **TIP:** If you want to get even deeper into how GoPro Studio Software works, in the top menu, select Help>Studio Manual for access to a pdf version of the manual. The Studio Manual has tons of helpful information.

*After you become comfortable with GoPro Studio, you may want a program like Final Cut or Premiere that has more capabilities, but to begin with, this program is enough to give you a good intro into video editing.

> **TIP:** When you are putting together a video for YouTube, you have to have permission to use music. There are a few sites that give you permission to use their songs for free (they usually ask that you give them song credits in exchange for the free music). Try out these sites which offer some free songs you can use for your videos if you plan to upload them to YouTube:
> http://incompetech.com
> http://leafylane.com
> http://www.melodyloops.com
> http://freemusicarchive.org
> YouTube also has a selection of free songs under Creator Studio>Create>Audio Library.
> Or you can buy songs at stock sites like iStock.com (they also have a free download every week if you sign up for an account).

Go Deeper
Once you get comfortable with the basics of video editing, check out the two options below for some extra effects.

Super Ultra Slow Motion Video Using Flux

As you have learned previously, to achieve true slow motion, you are limited to the frames that were actually recorded in the video. For example, when you conform video recorded at 120 FPS down to 24 FPS, you can only slow down the footage 5x to

maintain smooth video footage. When using the Speed slider bar in Step 2 of GoPro Studio, that is 20% of the original speed.

With Flux, you can slow your footage down to 3%-10%, so you can achieve super ultra slow motion far slower than the original frame rate would allow.

However, not all is perfect with the Flux option. To achieve super slow motion, Flux makes up frames that don't exist by analyzing the frame before and the frame after and filling in the space with digitally-created frames. For some scenes, this works really well, and for others, the results are far less than perfect.

Consider the following tips when you want to edit your clips into ultra slow motion:

• When possible, record at a high frame rate so that Flux doesn't have to create so many frames. The fewer frames that Flux has to digitally create, the better your chances for an effective result. However, Flux can be used with footage recorded at any frame rate.

• Choose the right video clips to apply Flux. Clean backgrounds and simple scenes will work better because they are more predictable. Flux really works best when the subject is against a plain blue or grey sky. Busy scenes with lots of background elements, such as bushes or water, make it harder for Flux to imagine what the missing frames should have looked like. You can try Flux out with any clips, but if the results come out strange, the background could be the problem.

• Choose the right section of the clip to apply Flux. Flux is best applied when the subject is above the horizon, so split the clip when the subject goes above the horizon and split the clip again before the subject comes back down. The resulting section would be the best bet to slow down for a successful application of Flux.

• GoPro recommends slowing down the footage to 3%-10% for the ultra slow motion sections, but Flux can be applied to any video that has been slowed down using the Video Speed slider bar in Step 2 of GoPro Studio.

To Apply Flux

1. In Step 2 of GoPro Studio, click on the thumbnail of clip you want to use in the section on the left side and drag the clip to the Storyboard.

2. Find a short section of the clip that you want to show in super slow motion. It's best to isolate a short 1-3 second clip because when you slow it way down, the clip will become a lot longer.

3. Split the clip before and after the section you want to slow down by dragging the slider to the points you want to clip and pressing the Split Clip icon on the left side above the Storyboard.

4. Make sure the clip you want to slow down is highlighted and under the Video tab on the right side, drag the Speed Slider to the left to reduce the speed of the video. When you drag the slider the Flux option will appear. Leave this box checked for the clip or clips where you want Flux applied.

5. Export your video. On the export dialog, there is another option to Apply Flux. Leave this box checked to apply Flux and export your video.

NOTE: Exporting with Flux applied takes considerably longer because GoPro Studio has to analyze and create new frames, so make sure you only apply Flux to the clips that need the extra frames.

Remove The Fisheye Effect

If you want to remove the wide angle fisheye look of your video, in Step 1 of GoPro Studio, click the "Remove Fisheye" box in the Advanced Settings dialog under the video quality.

This adds a lens adjustment to reduce the field of view so that the fisheye effect is reduced.

This option should not be selected if you want to keep everything that was in your original image. The Remove Fisheye option works well for particular shots that can afford to lose some of the image around the edges of the frame.

EDITING A TIME LAPSE OR NIGHT LAPSE VIDEO (from photos)

A time lapse is a fusion of photos and videos because you are capturing the scene through a long sequence of photos, but you display the scene as a movie. Time lapses are fun, creative additions to any video and they can give your viewers a great understanding of the overall scene.

This tutorial shows you how to edit a time lapse directly in GoPro Studio because of its simplicity and quality. For other good FREE editing software, you can also use iMovie (Mac) or Windows Live Movie Maker (PC).

Remember how you learned that 24 frames per second has the closest look to a movie. The goal here is to condense all of those time lapse photos into a video that plays at 24 frames per second so that each photo becomes a frame in the movie. You can play a time lapse at a faster or slower frame per second rate depending on the scene you recorded.

Time Lapse Video Editing Steps

#1- Select the Photos you want to use for the Time Lapse

1. Connect your camera to your computer and import the photos onto your computer.

2. All of the photos and videos that were on your camera's memory card will be mixed together, so sort through the photos you just imported and put all of the photos from the time lapse into a folder on your computer called "Time Lapse".

#2- Put together your time lapse video in GoPro Studio

1. Open GoPro Studio

2. In the top left go to File>New Project.

3. In the blue dialog box on the left, click Import New Files and select the folder with all of the photos for your time lapse.

4. When you click Open on the folder, GoPro Studio will automatically put together all of the photos into a movie format.

5. Save your project as you go along by clicking File>Save Project. Saving often will prevent you from losing any work if the program unexpectedly quits.

6. Click on the time lapse clip to bring it into the editing window.

7. Click on "Advanced Settings" on the bottom left below the video clip.

8. Under "Advanced Settings", there are three settings you should adjust.

 a. Change the Image Size. Because the photo file size is larger than you need for video, change the file size to 1440p. This will keep it at the same aspect ratio, but reduce the size so it is easier to work with.

 b. Frame Rate. GoPro Studio will automatically set it to 29.97 FPS. Unless you know that you want it to be a different speed, you can leave it at this rate and adjust the speed in the next step.

 c. Quality- Depending on how you plan to display your clip, you should choose Medium or High.

9. Save your new clip as a new file name in the empty white box below the frame.

10. Click the blue "Add Clip to Conversion List" at bottom right.

11. Click "Convert" at the bottom right and Proceed to Step 2 once the file is finished converting.

12. In Step 2, you can edit the appearance of the time lapse video like you did in the Editing Your Video tutorial. Depending on your computer's speed, your time lapse probably will not play back smoothly until you export it. You can adjust the speed, exposure and other settings using the dialogue boxes to the right.

13. If you want to scale the time lapse to Widescreen 16:9, you can use the 4x3 to Wide preset. If you would prefer to crop your time lapse to make it fit Widescreen without the distortion of the 4x3 to Wide preset, make sure the clip is in the storyboard and in the Framing box, adjust the Vertical slider until you are happy with the cropping.

14. When you are finished editing, click on Step 3: Export. This will bring up the export dialogue. If you chose to export at Standard 4:3 Aspect Ratio, choose Source under Presets. Otherwise, if you scaled it to a 16:9 Widescreen Aspect Ratio, select HD 1080p. To export a 4k video, select Custom and under the Image Size tab, select 4k. You now have your first GoPro® time lapse video!

> **TIP:** You can also simulate a time lapse look from a regular video clip using GoPro Studio. After importing your video clip in Step 1, click on Speed Up under Advanced Settings. When you click on Speed Up, a slider will appear with a box to insert a number, indicating how many frames you want to remove. A higher number will skip more frames and speed up the motion. You can also click on Motion Blur once Speed Up is checked to give your time lapse a blurred effect in between frames.

PULLING FRAME GRABS

A frame grab is a still image (photo) taken from a video clip. There are many reasons you may want to pull a frame out of a clip and there are several FREE, easy ways to do this. This tutorial shows you how to export a frame grab while editing your videos in GoPro Studio.

<u>**Steps for Exporting A Frame Grab**</u>

1. Once you are in Step 2 in GoPro Studio, make any aesthetic adjustments to the video before exporting your frame grab.

2. When ready to export the frame grab, slide the time bar to scroll to the exact frame in your video that you want to export. You can also move forward or backwards frame by frame by using the buttons on either side of the play button.

3. In the top menu, click Share>Export Still

4. Name the file and if you want to export the file at full size, choose Native under the Size to Export dropdown menu. GoPro Studio will export a JPEG photo file to the location you chose on your computer.

EDITING YOUR PHOTOS

As mentioned earlier, the photos you capture with your GoPro® camera are shot in JPEG format. Once again, there are tons of ways to edit photos and you will eventually find your own style, but this section is to give your photos that extra pizazz they need after coming straight from the camera.

Back in the days before digital, we selected our film based on its color and grain qualities. In the digital age, we give our photos a little more in postproduction. Images straight out of the camera look flat and dull, so this section is to help you process the images to make them look more like the scene you remember.

For this lesson, we will edit our photos with Gimp since it is a FREE and adequate photo editing software. (You can also make similar adjustments within Photoshop or Lightroom if you already have one of these programs).

If you plan to work with your image multiple times, it is best to save it as a Tiff. Jpeg files lose quality if you save them repeatedly, so saving your file as a Tiff will give you a safe master file to work with.

There are several edits you may want to make to improve your image quality. **Here is a step-by-step FREE method to add the pop your photos need:**

#1- Download GIMP photo editing software.

You can download Gimp for free from Gimp.org. Save it to your computer and open the program.

#2- Open the photo you want to edit in Gimp

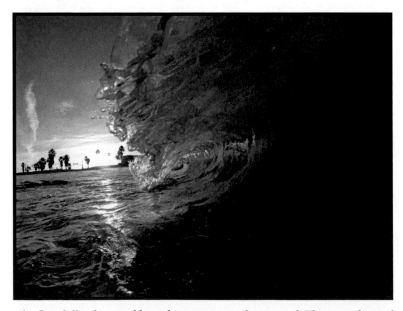

Original Image Above. Notice the flat, dull colors and how the image is underexposed. This was shot in backlit early morning lighting.

#3- Adjust Brightness/Contrast

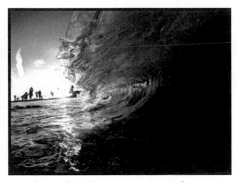

Brightness adjusted +51 and Contrast adjusted +52 in image on right

1. Go to Colors>Brightness Contrast
2. Adjust Brightness slider left or right to adjust Exposure
3. Adjust Contrast slider (usually to right to add more contrast which makes richer tones)
4. Click OK

#4- Adjust Saturation

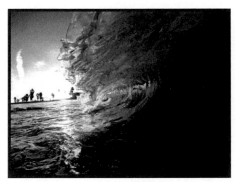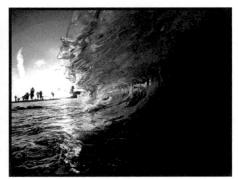

Saturation adjusted +35 in image on right

1. Go to Colors>Hue Saturation
2. Adjust Hue slider left or right to see how it affects the image
3. Adjust Saturation slider (usually to the right to add more color). Try to avoid over saturating the image. This is a quick, easy way to add a bit more color, but is frowned upon by most "photo professionals." The advanced LAB Color technique below is better option for improving color once you get the hang of editing photos.
4. Click OK

#5- Crop your image

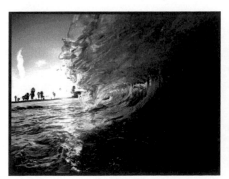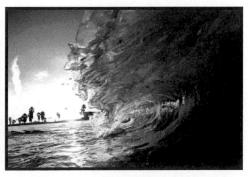

Image on right cropped to remove unwanted areas

1. Go to Tools>Transform>Crop

2. Drag box to desired crop and hit Enter.

#6- Save your image

If you are happy with your results, Go to File>Export and export your image as a JPEG or TIFF as desired.

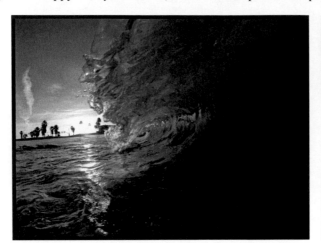 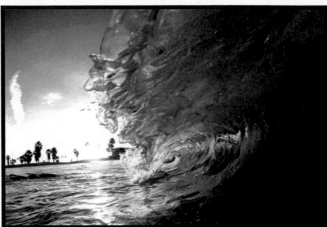

Original Image (left) and Final Edited Image (right)

TIP: Cropping your photo is the best way to remove the wide angle look of your photo. By cropping the edges of the frame and keeping the center of the image, you can remove the areas with the most distortion. The 12 MP photos from the HERO4 Black Edition give you plenty of room to crop your image and still have a high resolution photo.

Go Deeper

Advanced Technique: LAB COLOR

One way to give your image richness without damaging the quality of your image is to convert it to LAB color and then change it back to RGB. This technique is considered advanced because it involves more complicated steps to achieve the results, especially using Gimp (Photoshop is a lot easier). This is a much better way than using the Saturation slider to improve the colors in your image and an insider semi-secret technique. Here is how to do it for those of you who want to try it out:

1. Go to Layer>Duplicate Layer

2. Go to Colors>Components>Decompose

3. In the Extract Channels dialog box that pops up, choose Color Model>LAB and click OK.

4. Make sure the Layers bar is open to the left. If it's not, on the top menu under Windows>Dockable Dialogs click Layers.

5. In Layers bar to the left, turn off "L" Layer by clicking the little eyeball icon.

6. Click onto the "A" Layer

7. On the top menu, click Colors>Levels

8. Under Input Levels, change the values in the box to the left to somewhere around 40 and the box on the far right to a number around 215

9. Click OK

10. Now turn off the "A" Layer by clicking the eyeball icon to the left on the Layers bar

11. Click on Layer "B"

12. Repeat Steps 7-9

13. Click Colors>Components>Recompose

14. Go back to your original image without saving or closing the other one you were just working on. The top layer will be vibrant with color.

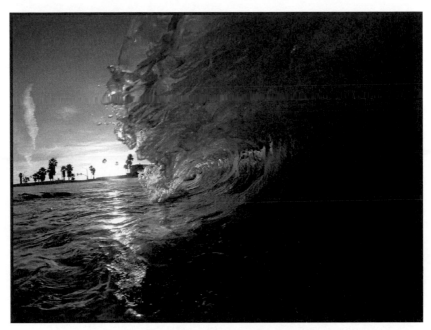

Image using just Lab Color to boost Color

15. On the Layer bar to your left, adjust the opacity percentage to your liking. This will minimize the amount of color you just added.

16. If you are happy with the results, under Layer on the top menu, select Merge Down and go to File>Export and export a JPEG or TIFF file as desired.

17. If you still need to adjust the image, you can adjust Brightness, Contrast and Saturation like you learned previously. After you are satisfied, export the image as in number 16 above.

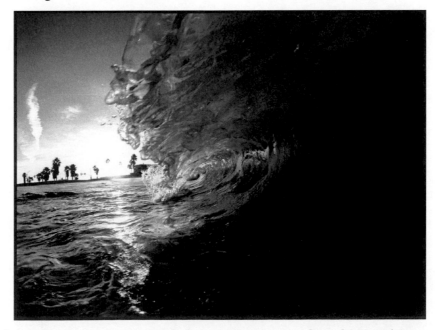

After Lab Color, the image was still dark, so Brightness was adjusted +33 and Contrast +40

Resizing Your Image

Yes, your GoPro® camera produces high quality large images, but if you decide you want to print an image larger than the original file size (a 30"x40" print @ 300 DPI for example), there are a few professional software options for resizing images without losing quality. These are not free (cost is usually $100-200), but they are worth the investment if you plan to resize a bunch of images or print large wall art.

The two most popular resizing software options are:

Perfect Resize Pro by OnOne Software (onOneSoftware.com)

Blow Up by Alien Skin Software (alienskin.com)

EDITING AN ACTION SEQUENCE

Photos taken on the HERO4 Black Edition in Time Lapse Mode at 12 MP WIDE at 1 photo every .5 seconds.

An action sequence is a digitally composited blend of photos taken using Burst Mode or Time Lapse Mode with your HERO4. Tips for setting up this type of photo are provided in Step 3- Capture Your Action. This cool looking effect can be done using Gimp or Photoshop. This tutorial shows you how to make an action sequence using Gimp. The process seems complicated at first, but once you get the hang of it, you can make these images rather quickly.

<u>Steps for Editing An Action Sequence</u>

1. Select the photos you want to use for the action sequence and put them together in a folder on your computer. If the subject ends up overlapping too much, you can turn off some of the photo layers when you are editing.

2. Open Gimp and open the first photo of the sequence by going to File>Open and select the first photo of the sequence. Click Open.

3. Add the rest of the photos to the file you are working with by clicking File>Open As Layers. Select the rest of the photos and click Add.

4. Reverse the order of the layers so that the first photo of the sequence is on top. Go to Layer>Stack>Reverse Layer Order.

5. Next add a layer mask to the top photo (layer). A layer mask lets you select which part of the photo you want to show up. Click on the top layer in the layer bar to the right. Go to Layer>Mask>Add Layer Mask. In the dialog box that appears, select Black (Full Transparency) and click Add. The first photo of the sequence will disappear from view.

6. Now you are going to bring back the pieces of the photo that you want to show up in your action sequence. Select the Paintbrush Tool.

7. On the left side below the tools, make sure the foreground color is set to White. Painting with white will paint away the Layer Mask, bringing back your subject. (If White is set as the background color, you can click the little arrow to switch White to foreground.)

8. Paint over the area where your subject was to bring your subject back onto the screen. If you need to adjust how much you painted, switch your foreground color to black. Black will cover back up the areas you painted white. Fine tune the layer mask until you are happy with the parts of the photo that are showing up.

9. If the subject in the layer below is too overlapping with the photo you are bringing back in to view, turn off layers until you see the layer you want to appear. Turn off layers by pressing the eye icon next to the layer on the layer bar to the right.

10. Repeat steps 5 through 9 for each photo (layer) that you want to show up, except for the bottom photo.

11. Finally, in the layers bar on the right, right click (Control + Click on Mac) and select Flatten Layers. You can now make any color adjustments like you learned in the previous section.

12. Export your file by clicking File>Export and save your file as your preferred file type.

If you prefer watching a tutorial video on how to do this, you can watch one of our video tutorials on YouTube that will walk you through the steps.
For the tutorial using Gimp, go to this address: http://bit.ly/1gJ3Ztf
For the tutorial using Photoshop, go to this address: http://bit.ly/GXoQv9

NOW THAT YOU'VE EDITED YOUR PHOTOS AND VIDEOS, YOU ARE READY TO MOVE ON TO STEP 5 AND SHOW THEM TO PEOPLE!

STEP FIVE
SHARE IT

Get Your Vision Out There For People To See

You've made it this far, now it's time to share your masterpiece. Even if your first video or photos are not masterpieces, friends and family will be excited to finally see you in action.

One of the easiest ways to share your footage is to use the GoPro App on your smartphone or tablet. With the GoPro App, you can copy photos and videos from your HERO4 to your device and then easily share them through Facebook, Twitter, Instagram, YouTube, or email.

SENDING FILES TO FRIENDS & FAMILY

If you were out filming and captured some great video footage of your friend or even a stranger who was out there shredding, you might be struggling to figure out how to share your video files. Even a short video file is too big for most email services, so you need to find a better way to share files. You can use one of the old school ways of sharing files such as putting the file on a USB flash drive and loading it onto your friend's computer.

If you don't have the convenience of physically sharing the file, there are a few free ways to send large files. (These are the current size limits at the time of publication.)

WeTransfer lets you share files up to 2GB as often as you like without signing up for any plans. All you need to do is to enter your email and the recipient's email address and link the file.

Hightail (formerly YouSendIt) offers a free plan that lets you send files up to 250MB, which isn't much if you are sharing 4k files, but it could be sufficient for short clips depending on the resolution. You can send much larger files with the paid plans.

DropBox has a free basic plan that lets you store up to 2GB that you can share with anyone you invite.

SOCIAL MEDIA

Social Media and Online Sharing Sites are great ways to get your experience out there. Social Media has undoubtedly contributed to the explosion in popularity of GoPro cameras. Many GoPro camera users are extremely active in social media communities. Just look at the number of fans on GoPro's Facebook Page. After you edit your videos and photos, here are a few FREE ways to get them out there for people to see.

Video-Sharing Sites:

You Tube - Most popular

You can create a channel and upload your videos for private or public viewing. YouTube is by far the most popular video sharing website so far, and with Google's backing, will continue to be. With a free account, you can upload videos smaller than 2GB and less than 15 minutes in length. You can upload as many videos as you like.

Vimeo - Creative/Non-commercial Videos

With a free basic account, you can upload 500MB of video per week, including just one HD video. The content must be original and non-commercial.

Blip.tv - Webshows, Revenue-Sharing

This site is geared towards users who want to produce continuous videos to create web shows, so you probably won't use this in the beginning, but it's a great resource to be aware of once you really get into video editing. The Basic account is free and 50% of any revenue from your content is shared with you. The great thing about Blip is that you can stream and download the original high-quality file.

Metacafe - Huge Audience, Revenue-Sharing

Metacafe is one of the largest online video entertainment sites. You can upload your content and share it with friends, get Facebook comments or just let the world find it. If you get enough views, you may earn a little side cash too.

Dailymotion - Huge Global Audience

This video-sharing site allows you to earn revenue from your videos and offers a free membership with unlimited uploads.

Photo-Sharing Sites:

Below are a few favorites out of the plethora of free photo-sharing websites available. Every one of the sites below has free accounts, but many of them are restrictive unless you upgrade your account. Check out these sites and see which one best serves your sharing needs.

Flickr

500px

Picasa Web Albums

Webshots

Instagram (short videos can also be shared)

Photobucket

Zooomr

Fotolog

Social Media:

And of course, there are the Social Media sites we use to share our lives. Most of them allow us to upload photos and videos, or links to videos.

Facebook - Post photos & videos

Pinterest - Pinterest is the perfect place to share ideas and pick up new tips on using your GoPro camera

Path - A more personal way to post photos & videos

Twitter - Post photos & links to videos

MySpace - Post photos & videos

Google+ - Share photos & videos

GATHERINGS

Use your footage as a reason to gather friends together and have a party. You are the filmmaker so have a pseudo premiere. But don't be greedy. Set your friends up to film them (if they don't have their own cameras). Edit your footage together into a mini flick and let everyone hoot and holler over the results. Here are a few ways to display your videos and photos.

Big Screen TV

Showing your videos on the Big Screen is an impressive way to watch your creation up close and personal. 4k Monitors, HD DVD Players and BluRay Players are currently the highest quality. If you are viewing your footage on a 4k television, see the 4k section in Step 6- Beyond the Basics.

Digital Projector

Pop up a white movie screen and watch your footage outdoors for a truly impressive display. Digital Projectors vary in quality (usually from 720p up to 1080p and even 4k) and price, of course.

Computer

Computer monitors are not the most social way to show your videos, but they are usually high quality and many of them can display 1080p.

PHOTO PRINTING

The HERO4 Black Edition takes high-resolution photos that allow for a wide variety of printing options. If you use the resizing software recommended in Step 4, you can use your GoPro® camera to make almost any size print you want.

With the plethora of creative photo printing options available, here are a few of the best:

Acrylic Face Mounts

The printed photograph is mounted behind a thin layer of acrylic and usually comes with a hanger mounted to the back, so it is ready to hang. Acrylic Face Mounting creates a modern look for wall art.

It's a tricky process, but Bumblejax.com is one lab that can produce these eye-popping prints for you.

Metal Prints

This printing process actually prints your photo directly onto aluminum, creating a unique effect, with lots of shine and realism.

Google "Metal Prints" or check out BayPhoto.com or Bumblejax.com

Gallery Wraps/Giclees

Make your photo look like a traditional wrapped piece of art by printing it on a gallery wrap. Print it on Metallic Photo Paper for extra vibrancy in your photo.

Google "Gallery Wraps" or check out BayPhoto.com for printing options.

CONGRATULATIONS, YOU NOW HAVE THE KNOWLEDGE AND POWER TO CREATE AND SHARE YOUR EXPERIENCES WITH THE WORLD! IN STEP 6, YOU WILL LEARN MORE TRICKS TO TAKE YOUR GOPRO FOOTAGE TO THE NEXT LEVEL.

STEP SIX
BEYOND THE BASICS

Take It Further

Once you have mastered the basics of using your HERO4 camera and see how much fun these cameras can be, you will probably want to add more flair and style to your videos and photos. When you are ready to add some extra features to your camera setup, these additional tips and accessories will help you get even better shots.

4K

The HERO4 Black is the first camcorder to record 4k footage at a usable frame rate. 4k is also known as Ultra High Definition (UHD) or 2160p (since other resolutions are defined by the line height and 4k refers to the width). **4k is 4x the resolution of 1080p**, which means there are 4x as many pixels in the footage. What this means for anyone watching 4k footage on a 4k monitor is incredibly clear realistic-looking video that looks like you can jump into. The difference can really be seen the closer you get to the screen.

If you want to watch your HERO4 Black footage in 4k, you need to record your footage in 4k. This limits you to recording at 30 frames per second or 24 frames per second in SuperView. Unfortunately these frame rates mean you will need to play your footage back at regular speed. However, you can still mount your HERO4 in all of the creative spots you can mount a GoPro and watch the footage in incredibly clear 4k resolution. Although you can record body-mounted shots in 4k, (and you will probably want to so you can capture the immersive GoPro angles in 4k) the lower frame rate is better suited for shots where your camera is mounted to your equipment, a vehicle, or on a tripod. High action shots are often shown in slow motion to reduce shakiness, but because 4k is played back at regular speed, it's best to set up stable mounted shots to prevent shakiness.

Because of the high resolution, 4k is incredibly demanding in terms of computer performance. If you are playing back your footage through your computer connected to a 4k monitor, your computer must also be 4k compatible or the footage will most likely play back choppy. Editing long clips also requires a lot of memory. If you are having trouble editing 4k, you probably need to upgrade your computer to make it compatible for 4k playback.

If you want to watch your 4k content from your camera directly to your TV, some TV's are capable of 4k playback with a USB card reader or USB drive. Check with your TV manufacturer to check compatibility. If you use an HDMI cable connected to your camera, 4k content will play at 1080p on a 4k TV, so using an HDMI cable is not recommended.

GOPRO APP

The GoPro App lets you use your phone or tablet as a live video remote. The App is a free download from the App Store (Apple) or Google Play (Android). Make sure your camera is updated through GoPro's update process and use your tablet or smart phone to set up shots and view what you've recorded. You can operate all of the functions of your camera, including switching modes, starting and stopping recording, and as a live viewfinder to compose your shots.

After filming, you can view, browse or even delete content on your camera's memory card.

The App also allows you to copy files to your device and then share the photos and videos on social media or through email. When you record video, your camera automatically records a LRV (Low Resolution Video) file along with the full resolution file. You can share the LRV file through the App, since it is a smaller file for uploading and viewing on small devices.

The App also provides the easiest way to update your camera's firmware through the wireless connection so you can always be up to date with the newest features for your camera.

If you want to integrate your smartphone as an LCD screen, there are a few creative mounting options to mount your camera and phone together for a more user-friendly experience. PolarPro makes ProView which mounts your GoPro to your phone. The Kampro Hand Grip is another creative mounting option that acts as a phone mount and a handle for your HERO4.

LCD BACPAC

Since the HERO4 Black Edition doesn't have a built-in viewfinder, using the LCD BacPac gives you the ability to use your Go-Pro® camera like an ordinary camera. When plugged in to the back of the camera, the LCD BacPac provides a view of what the camera is seeing. The LCD BacPac is very useful when your camera is not mounted and you are recording day-to-day activities, like hanging out on the beach with friends or family.

The LCD BacPac is also really useful for setting up angles to make sure you are getting what you want in the shot. Once you set up the angle and your camera is mounted, turn off the LCD BacPac (using the button on the side of the LCD Backdoor) to conserve battery life.

After a session, you can use the LCD BacPac to view your videos and photos. One of the great things about digital photography is the instant gratification of seeing your photos and videos right away. The LCD BacPac opens up this benefit.

The LCD BacPac has some intelligent features, like recognizing if you recorded burst photos or a time lapse. Instead of having to scroll through hundreds of photos of a time lapse sequence, it batches them all into one file for playback.

The LCD BacPac comes with three different backdoors- a standard waterproof backdoor (touch functions don't work with this backdoor), a touch backdoor (which is waterproof up to 10'/3m) and a skeleton backdoor. The touch backdoor is great for general use and is waterproof. But if you need to use the LCD BacPac during serious adventure sports, switch over to the standard waterproof backdoor for more protection.

Unfortunately, the Floaty Backdoor won't work with the LCD backdoors because obviously it blocks the view of the LCD screen.

The LCD Screen is a bit slow to respond sometimes, it eats up the battery life and it prevents you from using the Battery BacPac, but it's a great accessory to have on hand.

MAKE YOUR TIME LAPSES STAND OUT

In addition to using Time Lapse Video or Photo Modes to create a time lapse video, you can also speed up regular video footage for time lapse clips. Speeding up regular speed video footage to create a time lapse effect takes up more computer memory during editing and fills up your video card faster so it is not ideal for long duration time lapses. However, it can be useful for short time lapse clips. If you missed it, see the tip at the end of editing a time lapse video in Step 4 to learn how you can make any video look like a time lapse.

Because time lapses are time-consuming to record, when possible, set your time lapse shot up with the LCD BacPac or your

phone/tablet using the GoPro App. If you are using an egg timer or camera slider (see below), look at the beginning shot, but also make sure the composition looks good at the end of the movement. If you do use an LCD BacPac, make sure to turn it off once you have your shot set up so that you can get the maximum battery life out of your camera.

Use a Battery BacPac for extra battery life for long time lapse shots. If you are making really long time lapses, you can use an external power supply, like the Heavy Metal 5500, that powers your camera through the USB cable. If using an external power supply, you will need to use the Frame or the Skeleton Housing so you have access to the USB port on your camera.

Although your camera should be mounted in a stable position when recording footage for a time lapse, adding movement gives time lapse shots a professional look. There are a couple of simple techniques you can use to get this slow-moving effect.

Use An Egg Timer

The Egg Timer Mount (as shown in the Custom Mounts in Step 2 - Mounting) will give your time lapse shots a rotating movement that creates a cool effect.

Use a Camera Slider

A camera slider provides a smooth track for you to move your camera from left to right or vice versa during a time lapse.

You can make your own camera slider or buy one (they aren't cheap), but for a really good time lapse, you will need to add a mechanism for it to steadily and slowly move across the slider. For short time lapse shots, a string and some patience is one cheap and easy way to do this.

More Time Lapse Ideas

• Record an artist making a drawing or a painting. Shoot photos at a relatively fast rate depending on the predicted time of the project. 1 frame every 2 seconds would work well for a 45 min to 1 hour-long art project.

• Mount your camera to the back of a standup paddleboard for a downwind paddle or a bike for trail ride. Try to get a stationary object in the foreground, like the board or a bike seat so you don't make your viewers dizzy. The moving action in the background makes for an exciting action time lapse. Short intervals typically work well for action time lapses.

• Sunset at the beach or lake. Try to choose a day with scattered clouds, and it's even better if the clouds are moving quickly through the sky. The movement of the clouds, the reflections on the water and the dwindling light will create dramatic time lapse clips. Try to frame your shot so there is some movement close to the foreground, like breaking waves or trees blowing in the wind. Because of the wide-angle lens on the HERO4, movement that is far off in the distance won't make much of an impact.

SMART WIFI REMOTE

The built-in WiFi is one of the most useful features of the HERO4 camera. The Smart WiFi Remote must be purchased separately, but it really opens up the possibilities for different shots.

The Smart WiFi Remote is waterproof up to 33' (10m) deep and can control your camera from up to 600'/180m away in the right conditions away so you could even have a friend on the beach push the shutter button for you. The WiFi signal does not work underwater and will lose the connection within a few inches from the surface. The camera should automatically reconnect to the remote once you bring your camera back to the surface of the water.

When using the WiFi Remote with one camera, the LCD Screen on the remote mimics the LCD display on your camera, and you can instantly control your camera from a distance.

The WiFi Remote can control up to 50 cameras at once, so if you get more than one WiFi-enabled GoPro® camera, you can control all of them at the same time. When you have more than one camera connected to the WiFi Remote, the remote LCD display

will tell you the number of cameras connected, the recording mode and the remote's battery status.

To Connect Your Camera To The Remote:

Make sure your camera's WiFi Signal is turned on by holding down the Settings/Tag Button until you see the blue flashing WiFi Indicator light. Next, turn your remote on into pairing mode by holding down the remote's Shutter Button (the button with the red circle) and then pressing the Mode Button. Keep pressing the Shutter Button until you see two arrows indicating that your remote is connecting to your camera.

Try out these uses for the WiFi Remote:

Action Self-Portrait Photos

When your camera is mounted to your equipment and is unreachable, use the remote for action photos in Burst Mode to get a great sequence at just the right moment. Carry the remote in your hand (or even better, attach it to your wrist with the Velcro strap that comes with the remote) and push the Shutter Button (the Red Circle) when you want to start the sequence.

Inaccessible Angles

If your camera is mounted somewhere inaccessible, like on the wing of an airplane or the side of your truck while you are off-roading to some remote surf spot, use the WiFi remote to start and stop the video during the exciting parts of the ride.

Undercover Angles

If you are trying to record footage without anyone noticing, you can set your camera in the right spot and start recording or taking photos as soon as the action starts. This works great for nature shots because animals are more likely to approach your camera without you standing next to it.

Polecam

If you have a polecam setup, use the WiFi remote to shoot Burst photos or start and stop recording video without having to reach your camera. By using the remote, you can get more distance between you and the camera and still have access to push the shutter button. Strap the WiFi Remote around the base of your pole using a piece of Velcro and shoot away. Some premade poles (like the GoScope and Remote Pole by SP-Gadgets) have mounting spots for the remote.

BATTERY BACPAC

The Battery BacPac gives you double the battery life, so if you find you are running out of batteries, the Battery BacPac will help out. The Battery BacPac is really useful for long time lapse clips. Having a spare battery on hand is also a good option.

OFF THE GRID HERO4 SETUP

GoPro camera enthusiasts live outside of the box. With these accessories, you can step away from your computer for days or weeks and still be able to record your adventures:

Portable Battery Charger

Out of the box, the only way to charge your HERO4 is to plug it into your computer and wait for the batteries to refill. The Go-Pro Auto Charger or Wall Charger lets you recharge with a wall socket or your vehicle's lighter socket giving you the freedom to get out there and disconnect.

Portable Data Storage

There are lots of great portable options for storing your photos and videos when you are away from your computer. The Digital

Foci Photo Safe II 500GB (around $150 US) is one of the best picks because of its price, storage capacity and built-in MicroSD card reader that will read the MicroSD cards from your HERO4. This will give you plenty of storage so you can empty your memory card onto this device and keep filming.

FILTERS

Backscatter, GoPro and Polar Pro offer a variety of filters to enhance the colors and quality of your photos and videos.

Polarizer

For bright sunny days with lots of glare, use a polarized filter to reduce glare and light. A polarized filter will reduce reflections from the water enhancing water clarity and also make the sky appear darker blue.

Red Filter

In tropical blue water, use a red filter to enhance the colors underwater. A red filter works best as you get deeper underwater (about 10 feet below the surface and below) where the colors of the spectrum fade away.

Magenta Filter

When the water is green, use a magenta filter to reduce the green tint in your footage. As with the red filter, this filter is most effective when used below 10 feet of depth.

MACRO LENSES

With the HERO4, anything further than 12 inches away from your lens will be in focus. If you want to film close-ups closer than 12 inches away, a macro lens allows you to film up to 3 inches away and capture great in-focus close ups. A macro lens is a specialty lens used specifically for close-up macro shots and is not for general shooting. PolarPro offers an easy to use snap on option. Backscatter makes a macro lens for underwater use that works with their Flip filter system.

STEADICAMS

If you are really into video and would like steadier shots, consider getting a steadicam. These stabilization devices make a huge difference in handheld shots. They are pricey ($125+ US), but they really do create smoother shots. The Steadicam Smoothee is one of the more reasonably priced options.

MICROPHONES

If audio quality is really important to you- for an interview, YouTube clip, or whenever you need really clear audio- consider using an external microphone. GoPro makes a microphone adapter that allows you to plug any 3.5mm microphone into your camera. The connector plugs into the USB port so it cannot be used when your camera is in the water housing. The Frame Mount does have a port for the USB, so this is the best option if you want to use a microphone. Using a microphone is not possible while filming in the water.

NOW GET OUT THERE AND HAVE FUN!

TROUBLESHOOTING

With the HERO4 Black Edition, GoPro appears to have performed the proper testing and the cameras are running smooth. Some of the following problems have been reported with previous models, so if you encounter any of these problems, try these solutions first. You can always contact GoPro's customer support via telephone and they will troubleshoot any problems with you right away. See GoPro's website for their customer service contact info for your country.

CAMERA MALFUNCTIONS

If you experience any of the following problems: **first try the solution offered**. If the problem happens repeatedly, **reinstall your camera's firmware** by performing an update through GoPro's website, through the GoPro App or through GoPro Studio. It's possible that the firmware did not install properly during the initial installation. If the problem persists, contact GoPro's customer support.

Problem: Your camera's LCD Status Screen is frozen up and unresponsive.
Solution: Perform a hard reset by holding down the Power/Mode Button for 10 seconds. This will not erase your videos. If you continue experiencing this problem, reinstall the firmware.

Problem: The camera heats up when recording.
Solution: This is normal, especially when filming at high resolutions or frame rates. If your camera turns off due to overheating, you can change the backdoor to a Skeleton Backdoor (if you do not need your camera to be waterproof) to allow more air flow. If you continue to experience overheating, turn off the WiFi or remove any BacPac being used. Also, recording in short stints will reduce the strain on your camera.

PLAYBACK ISSUES

Problem: Your computer is not recognizing the memory card when your camera is connected to your computer.
Solution: Make sure your computer is running the current operating system.

For Mac Users: Some programs may interfere with the communication between your camera and computer. Usually you can import the footage using Image Capture, which is located in your Applications.

Alternatively, if your computer has an SD Card slot, remove the micro SD card and use the micro SD card adapter to transfer your files.

Problem: Your video plays in fast forward after transferring it to your computer.
Solution: Import the video to GoPro Studio. Convert the frame rate in GoPro Studio. If this does not solve the problem, reinstall the firmware on your camera.

Problem: There is only audio and no picture.

Solution: Reinstall your camera's firmware by performing an update through GoPro's website, through the GoPro App or through GoPro Studio. If the problem continues, contact GoPro's customer support. You may need to get a replacement camera.

Problem: Choppy video playback. Some users experience choppy video playback. This is mainly due to the highly compressed video files that require a lot of work from your computer. GoPro cameras use a very complex compression codec called h.264 to store a lot of video footage in a relatively small amount of memory. Your computer will most likely have the most trouble playing high resolution or high frame rate files. The good news is that your files are recorded properly. The not-so-good news is that your computer may not be able to handle the large video files.

Solution: First make sure you transfer your files to a folder on your computer before attempting to view them.

Next, import your video into GoPro Studio and convert the portions of the clips you want to watch. In Step 2: Edit of GoPro Studio, if your video is still playing choppy, set the playback quality to Better (Half Resolution) or even Good (Quarter Resolution) if you are still experiencing choppy playback. This will allow most computers to play the video footage smoothly, as it should be seen.

If you are still experiencing choppy playback, check to make sure your computer meets the minimum system requirements as shown in the User Manual. If your computer does not meet these requirements, you may need to update your computer. Alternatively, you can record in a lower resolution, but most likely, you did not buy the HERO4 Black Edition to record in the low-resolution settings.

EDITING ISSUES

Problem: GoPro Studio crashes when exporting 4k video.

Solution: Check to see if your computer supports 4k playback. If your computer does not support 4k playback, you may not be able to export videos to 4k.

Until you upgrade to a 4k-compatible computer, you may need to export your files at 2.7k or 1080p.

If you are experiencing any other issues with your HERO4 Black Edition or any of GoPro's other products, contact their Support team.

GLOSSARY OF TERMS

ASPECT RATIO- describes the proportional relationship between an image's width and height.

DEPTH OF FIELD- the distance between the nearest and farthest objects in a scene that appear in-focus in an image.

DPI- Dots per inch, a measure of the resolution of printers, scanners, etc.

EXPOSURE- the total amount of light allowed to fall on the photographic medium (photographic film or image sensor) during the process of taking a photograph.

FIELD OF VIEW- The area which can be viewed through your camera.

FISHEYE LENS- An ultra wide-angle lens that produces strong visual distortion intended to create a wide panoramic or hemispherical image.

FRAME GRAB- a still image (photo) taken from a video clip.

FRAMES PER SECOND (FPS)- the frequency (rate) at which your camera produces unique consecutive images called frames.

JPEG- A commonly used file format for creating smaller compressed files. The compressed image type is commonly referred to as a "JPEG."

LENS PORT- The glass or plastic piece on the water housing directly in front of the lens.

MICRO SD CARD- A compact flash memory card used in GoPro® HERO4 cameras.

MP- stands for megapixel, which means roughly one million pixels. The resolution of digital cameras is often measured in megapixels.

PIXEL (p or px)- the smallest single component of a digital image. In simple terms, the "dots" that make up an image.

PPI- Pixels per inch, a measure of the resolution of display screens, scanners, and printers. The difference between PPI and DPI is that PPI is often used when referring to monitor resolution, whereas DPI is often used when referring to printed resolution.

PSD- An image file type created specifically for use in Adobe Photoshop®.

RESOLUTION- A term to describe the amount of detail an image holds. It can be measured in various ways depending on the medium it is describing.

RAW- An image file as captured by a digital camera or scanner prior to it being further processed for viewing. Sometimes referred to as a "digital negative."

SLOW MOTION- The action of showing film or playing back video more slowly than it was made or recorded, so that the action appears slower than in real life.

TIFF- An image file format for storing images without losing image quality.

TIME LAPSE- a technique where the frequency at which frames are captured (the frame rate) is much lower than that used to view the sequence. When played at normal speed, time appears to be moving faster and thus lapsing.

WATER HOUSING- A waterproof case that fits around a camera to protect it from water damage.

Made in the USA
San Bernardino, CA
28 February 2015